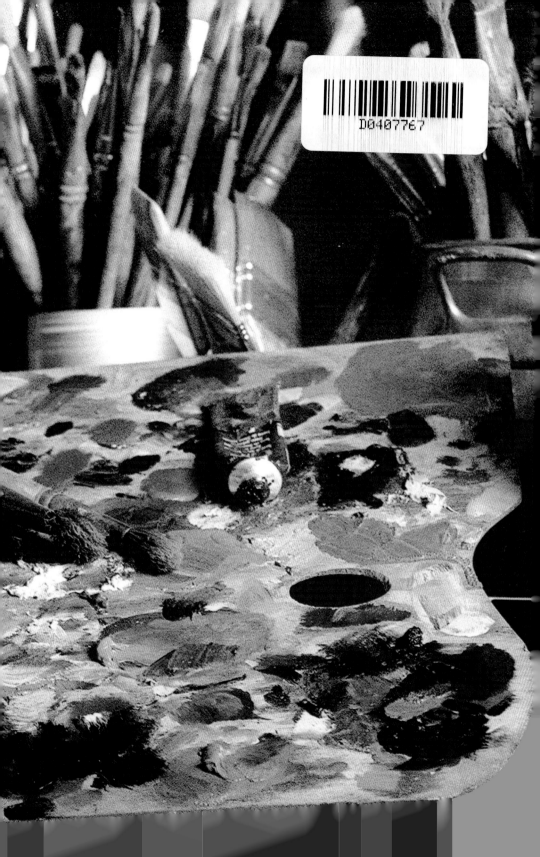

Vanished Splendors

A Memoir

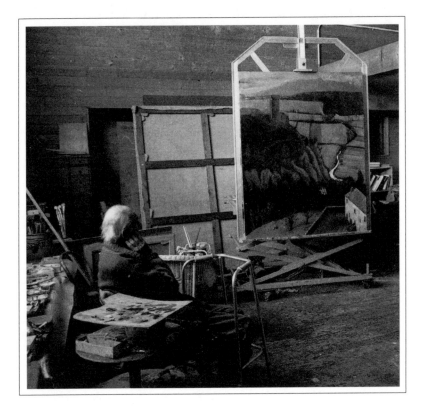

Vanished Splendors

A Memoir

BALTHUS

As told to
ALAIN VIRCONDELET

Introduction by
JOYCE CAROL OATES

Translated from the French by
BENJAMIN IVRY

An Imprint of HarperCollins*Publishers*

Published in French as *Mémoires de Balthus* by Editions du Rocher.

VANISHED SPLENDORS: A MEMOIR. Copyright © 2001 by the Estate of Balthasar Klossowski. English translation copyright © 2002 by Benjamin Ivry. Introduction copyright © 2002 The Ontario Review, Inc. All rights reserved. Printed in the United States of America. No part of this book may be used or reproduced in any manner whatsoever without written permission except in the case of brief quotations embodied in critical articles and reviews. For information address HarperCollins Publishers Inc., 10 East 53rd Street, New York, NY 10022.

HarperCollins books may be purchased for educational, business, or sales promotional use. For information please write: Special Markets Department, HarperCollins Publishers Inc., 10 East 53rd Street, New York, NY 10022.

FIRST EDITION

Designed by Jessica Shatan

Printed on acid-free paper

Library of Congress Cataloging-in-Publication Data has been applied for.

ISBN 0-06-621260-X

02 03 04 05 06 ❖/RRD 10 9 8 7 6 5 4 3 2 1

Contents

Publisher's Note[*]

The painter Balthus wanted his memoirs to be published during his lifetime. Although most of the text was written before his death, we wanted to include the last material he dictated, like the rest of the text, to Alain Vircondelet. This way, Alain Vircondolet could put the memoirs into shape in the most scrupulous way.

We wish to thank his wife, Countess de Rola, and his children, who have understood the importance of this testimony, so that the whole world may learn and be influenced by it.

Finally, we'd like to thank Alain Vircondelet, who collected the painter's observations and comments meticulously and passionately, during many stays at the Rossinière chalet, faithfully respecting a text that henceforth and forever belongs to one of the great masters of twentieth-century painting.

[*]This note appeared in the original version of *Vanished Splendors*, published in French as *Mémoires de Balthus*.

A Note to the Reader

Balthus's memoirs must be read as his legacy, as last words offered at the end of a life that spanned a century. They were murmured in a whisper, a fragile whisper that gradually faded and yet managed to be overtaken by the youth of still-intact memories, as if their return strengthened his life, renewing his energy.

These memoirs are the result of two years' work during which Balthus confided in a single person as he had rarely done during his entire lifetime. The meetings enchanted him and made him very happy. He wanted them to be understood as lessons in life, the last teachings of a painter who thought, as Péguy supposed, that "only tradition is revolutionary" and determinedly modern.

ALAIN VIRCONDELET

Foreword

THE PAINTER AT THE MIRROR

Jules Laforgue wrote, "The dead / are discreet, / sleeping / well in a cool place . . ."

Balthus, excuse me for interrupting your sleep. Eternity is so long, and its pathway so uncertain, that I prefer to entrust these lines to my guardian angel. On the day Alain Vircondelet's book is published, may he give them to you.

On February 24, 2001, I walked alongside your wife, daughter, and sons, following the country sleigh that carried your coffin from Rossinière's minuscule church, where cardinals jostled one another, to the plot acquired the night before, to be fertilized with your body. I thought of Victor Hugo's funeral. He also chose a poor man's hearse to take him to his final resting place.

When a genius is buried, it matters little whether the funeral is national or limited to the family. Native silt is as good as the Pantheon. Both become receivers of the ineffable.

One day, the children of the new millennium will examine the painting of our time and they'll be astonished to find that the twentieth century that gloried in so many schools was dominated by two solitaries: Balthus and Picasso.

Picasso, because he imposed a new world vision on people, destroying and rebuilding what the Lord created, transforming a proper name into a noun.

Balthus, as a lover of purity and ambiguity, made appearances yield and transcended them. After Masaccio and Piero della Francesca, whom he loved above all others, he became the painter of the soul.

The great Italian painters represented the link between mysterious immateriality and the body's fragility, their spiritual lucidity and blind senses, through portraits of heavenly creatures who, tormented by Lucifer, sprang up from the void.

Instead of them, Balthus preferred budding young girls, victims of puberty's agonies and delicious torments.

Do angels have a gender? Or do they contain both, like Tiresias? Balthus was oblivious to the Byzantine debate, and transformed their winged lightness into disturbing stillness . . . There are no sly winks in Balthus, but the fervor of an insolent and meticulous heart.

His adolescent girls inadvertently spread their legs in an imperceptible manner, in order to celebrate the holy conch where the earth originated. His art is a religion where sin is never impious,

and he reminds us that the sacred message must not be left within the reach of children. The Father so esteemed flesh, its desires, temptations, and failures, that he shaped His Son with them, bringing them to mankind. Desire is the soul's inspiration, the internal and external quality that Balthus revealed in his models' gaze.

When melancholy fell like snow over Grand Chalet, buried in frost by the wind, Balthus endlessly took my hand in order to warm his. This endlessness seemed brief to me. This predator of heat burned down cigarette after cigarette, and shared hidden secrets with me in his cracked voice. He told me a few days before his death, "I don't know if I ever told you, Maître Paul"—that's what he always called me—"about my first meeting with Antonin Artaud."

Without waiting for my response, he added, "Do you know what his first words were? 'Balthus, you are my double!' " I still hear his choked laugh while the cats at his bedside softly purred. He continued, "Indeed, we resembled each other. We shared the same frenzy for freedom, the same passion for ardent rationality that Apollinaire loved. Maître Paul, I tried to express this in my canvases."

Then his hand grew heavy in mine, and Balthus fell asleep.

The discovery of Artaud influenced him far beyond the sets for *The Cenci* that he designed at the poet's request. Rossinière's hermit and the Vieux-Colombier's urchin were both in the service of a cruel and incandescent beauty. From initiates, they turned into initiators.

They frequented the Surrealist group and its oneiric rogues. But they refused to submit to Breton's papal bulls and encyclicals,

to blend into an outrageous, puerile coterie, or attain freedom by way of a labyrinth.

Getting away from Surrealism was more vital than joining it. The movement owes more to its deserters than to its veterans. Breton was its Boileau and his manifestos were its *Poetic Art*.

Balthus—unlike Dalí or even Magritte—never used Surrealism as a crutch or foil. He absorbed the essence of its message, but not its affectation and flashy propaganda. And he made paintings that were ineffably Balthus. His wise, pensive canvases eschewed premeditation. They didn't seek to dazzle; they bewitched. Not to disturb; but to disrupt. Not to provoke; to enchant. Making grace into a mirror of shamelessness, he offered each day its reformulated light, in colors of earth and skin.

Balthus isn't a stage director, but an artisan who bleeds silence, a poet who shakes up conventions. He makes eroticism into a hymn, to the disappointment of voyeurs and idlers.

The first time I met him, a miracle occurred. A strong, new friendship heedless of time was born between the old man as young as love, and the old young man I was and whom I hope to remain for a while. I gave him my meager assets, and he enriched me with his treasures. He allowed me to watch him paint, and taught me how to decipher the invisible, in the space of a painting.

Who can bring back Balthus's hand and gaze?

The country sleigh has finished its ride. We are before the burial place, next to the alchemist Stanislas, the esthete Thadée, the lovely jewelry designer Harumi, and Setsuko, the painter of golden cherry trees. Soon, the coffin vanishes beneath a shower of roses.

I've known the lacerations of so many famous painters' legacies, and I told myself that this unity, calm, and peace were Balthus's last masterpieces.

<div align="right">

PAUL LOMBARD

Peking, August 2001

</div>

Introduction

In 1965, upon the occasion of a retrospective of his work at the Tate Gallery in London, Balthus sent a telegram to the art critic John Russell, who had requested biographical information: "Begin this way: Balthus is a painter about whom nothing is known. Now we may look at his paintings."

Such injunctions have a way of inciting, not dampening, the curiosity of others, as Balthus would discover. The more with-drawn and inaccessible an artist declares himself, the more the world clamors to know him—"know" in the most intrusive and vulgar of ways; when the artist is one of the great originals of twen-tieth-century European painting like Balthus, this clamoring can spill over into rudeness and exploitation. In preparing *Balthus* (1996), the artist's son Stanislas Klossowski remarked that Balthus was disappointed with "virtually everything written about him, which is all too often characterized by a combination of mis-understanding and sheer nonsense." In this memoir, Balthus makes the plea repeatedly that art should be recognized as

autonomous, and not biographically linked: Painting is a spiritual act, a kind of prayer ("To paint is not to represent, but to penetrate, to go to the heart of the secret" [page 70]); in words very like T. S. Eliot's in "Tradition and the Individual Talent," in which Eliot memorably argued that art isn't an expression of personality but an escape from it, Balthus claims:

> My memory of the century I have lived through and the people I've met remains intact, but it isn't chronological. Rather, it is analogical, with one event and anecdote linked to another, weaving my life's canvas. I've often thought that the best value and finest virtue was in keeping quiet and creating silence. I never interpreted my paintings or sought to understand what they might mean. Anyway, must they necessarily mean something? That's why I so rarely discuss my life, finding it useless to describe it. Rather than expressing myself, I've busied myself with expressing the world through painting. Besides, the moments of my life are drowned in memories of wartime; so many things almost killed me that there is something derisory and aleatory about chronicling one's life in a well-designed way. [page 25]

There is no reason, in theory, why an artist's work must inevitably be linked to the "private life" that brought it into being. Still less is there any reason to link it with the social and political history of its time. For the artist, the instinct to create art predates the content of his art: The instinct is likely to begin in early childhood, in the sheer playful discharge of energy, devoid of significant

content and certainly of "ideas." In time, the artist acquires content, perhaps even "obsession": But these are the raw material of art, shaped, like a sculptor's clay, to the forms of his imagination. That Balthus would seem to have fantasized "Balthus" into being suggests the need of the artist to construct an artist-self by way of which his art comes to be produced. But the biographical, the anecdotal, the literal are only distracting when introduced into art or literary criticism, for the temptation is to trace works of the imagination back to their presumed "origins" in the artist's private life. Responding to the sentimental excesses of the Romantic tradition and the "public ecstasies" accruing to the Brontë sisters, Henry James remarked impatiently: "Literature is an objective, a projected result; it is life that is the unconscious, the agitated, the struggling, floundering cause."

James also remarked, "The artist's life is his work, and that is the place to find him."

These are propositions that might have been uttered by Balthus himself. For decades, through his long life and increasingly distinguished career, Balthus had the reputation of being the most reclusive and secretive of artists; except for a period in the 1960s when, at the bequest of his friend André Malraux, then French minister of culture, Balthus undertook a complete restoration of the Villa Médicis, seat of the French Academy in Rome, Balthus preferred to live and work in isolation in remote areas of France and the Swiss Alps. He worked very slowly on his paintings, sometimes taking as long as twelve years to complete a canvas; he refused all

requests for interviews, photographs, visits. This memoir dates from Balthus's last years, in Montecalvello, a meticulously restored eighteenth-century chalet near the village of Rossinière, Switzerland, where he lived with his second wife, the Japanese-born artist Setsuko, and their daughter, Harumi. (The most remarkable of Balthus's late paintings are the bizarrely Surrealist *Grande Composition au corbeau*, 1983–86; *Nu couché*, 1983–86; and the intricately structured *Le Chat au miroir II*, 1986–89, and *Le Chat au miroir III*, 1989–94. *Katia lisant* was painted over a period of eight years from 1968 to 1976, and the lesser-known, atypical *Japonaise à la table rouge* and *Japonaise au miroir noir* were painted over a period of nine years from 1967 to 1976.) In this place of beauty and seclusion in the Alps, Balthus immersed himself in his art as a mystic immerses himself in God:

> *I always begin a painting with a prayer, a ritual act that gives*
> *me a means to get across, to transcend myself. I firmly believe that*
> *painting is a way of prayer, a means of access to God. [p. 17]*

In this entranced region, the artist enters into a communion of sorts with his great predecessors of the classic past, both European and Far Eastern; certain of Balthus's most haunting canvases look as if they've been unearthed from a lost civilization. Avoiding the specifics of memory in this memoir, which would yield a very different sort of document, Balthus alludes only in passing and in a curious aesthetic context to distressing wartime memories:

My painting was described as "glaucous" [glauque]. What could they have meant by that? . . . Insofar as glauque means "blue-green in color," we didn't see any connection. Was the word used in its moral meaning, namely "perverse, dubious, and steeped in a shady world"? Of course, that's the way the adjective was used. This nonsense about my painting made me smile. I secretly noticed that it wasn't entirely disagreeable to be thought of in this way. The young girls I've sketched and portrayed, including the willfully scandalous Guitar Lesson, can be seen as revealing compulsively erotomaniacal behavior. I've always refuted this, seeing them as angelic, heavenly images . . . The adolescent agitation of my young girls' bodies reflects an ambiguous nocturnal light along with a light from heaven.
[pages 203-204]

Which leaves the issue as it should be, ambiguous.

A formalist in art, as he was aristocratic and conservative in life, Balthus revered such Italian masters as Piero della Francesca and Masaccio, whom he saw as artists of scrupulous modesty and precision. Nothing seems to have more offended Balthus than the self-conscious, highly engineered (and publicized) art of the Surrealists under the tutelage of André Breton.

The humility of the early Italian painters constantly compels me to imitate them. Personality cults by contemporary painters infuriate me. One must seek the opposite, fade away more every day,

find exactingness only in the act of painting, and always forget one-self. Instead, one sees nothing but self-exhibitionism, personal con-fessions, intimate avowals, auto-voyeurism, and egoistic declarations. I often say that one mustn't try to explain or express oneself, but rather the world and its darkness and mystery . . . Real modernity is in the reinvention of the past. [page 81]

In his late seventies, perhaps as a result of failing eyesight and health, which made lengthy workdays in his studio more difficult, Balthus began at last to concede to interviews, including even tele-vision documentaries; he allowed his photograph to be taken, notably by his friend Henri Cartier-Bresson at Le Grand Chalet in Switzerland; so began the artist's acknowledgment of his place in twentieth-century European art as "Balthus." Two years before his death Balthus began a memoirist project "as told to" his friend Alain Vircondelet, which was published in France in 2001 as *Mémoires de Balthus.*

The memoir is purposefully unstructured and impressionistic, a sequence of reveries that are nostalgic and brooding by turns, idealistic, argumentative, mystical. There is no gossip here, and virtually no confessional material. Balthus's first wife and his chil-dren are scarcely mentioned. Yet the memoir is laced with autobio-graphical asides that rivet the attention (how many young artists began their careers at the age of twelve with the publication of a book of cat drawings—*Mitsou,* 1922—with an introduction by Rainer Maria Rilke, who happened to be Balthus's mother's lover at the time?); it evokes a vanished Europe reminiscent of the pre-

Revolutionary Russia eulogized by Nabokov in *Speak, Memory*. Unlike Nabokov, however, Balthus presents himself as appealingly modest: " I have no real life to write about, only scraps of memory which, when connected, create a woven version of myself. The man and his painting are one and the same, and my only real statement is through painting." [pages 48–49] And, "Perhaps there really is nothing to say, and all that matters is observing . . . I look at [my canvases] and enter into their mystery." [page 74]

Like the gentle riddlesome admonitions of a Zen master, such statements recur through the memoir yet are misleading, for Balthus does provide us with a sense, however abbreviated, of what it was to have been born into an educated, cosmopolitan Parisian society in the early years of the twentieth century, the son of a Polish-born art historian who counted among his friends such Neo-Impressionist painters as Bonnard and the intellectuals Maurice Denis and André Gide. (Unfortunately the Klossowski family lost everything in 1914 as a result of Balthus's father's investing all his savings in Russian railway stock.) As a young man, Balthus moved in circles that brought him into contact with Picasso, Derain, Giacometti, Artaud, and Camus; though he died in 1926, when Balthus was only sixteen, Rilke exerted a strong influence on Balthus throughout his life. (It was Rilke who provided Balthus with a predominant metaphor for his art: the "crack" in reality that is the way in to mystery, magic; the disorienting sense, in a typical canvas of Balthus, that "anything might happen." [page 72])

The memoir is a key to understanding the interior logic of Balthus's enigmatic paintings, symbolically if not literally.

(Though Balthus does describe *Le Cerisier*, 1940, which depicts an adolescent girl climbing a ladder into a strangely shaped cherry tree, as an emotional, nostalgic reaction to the war—for this reason, perhaps, it is not one of Balthus's memorable paintings.) We are drawn to see beyond the arresting, dreamlike images of the familiar *La Rue* (1929), *La Montagne* (1935–37), *André Derain* (1936), *Le Salon* (1942), and numerous other studies of adolescent girls in moods of reverie what Balthus presents as an obsessive spiritual interiority given an aesthetic shape through obsessive painterly craftsmanship:

> *No one thinks about what painting really is, a skill like that of a laborer or farmer. It's like making a hole in the ground. A certain physical effort is needed in relation to the goal one sets for oneself. It is a discernment of secrets and illegible, deep, and distant paths that are timeless. [page 21]*

Balthus is vehement in rejecting "ideas" in art, yet there emerges in the memoir a distinctly Balthusian iconography of the idealized (female, prepubescent) human form always depicted in states of friezelike immobility, as if captured in the artist's dreaming mind. (See the unsettling *André Derain*, in which the painter's hooded eyes and massive figure in a dressing gown loom in the foreground while, in the background, a childlike, partly unclothed, and seemingly insensible model is seated in a chair. The viewer is led to think that the model has been used, or misused, in ways other than for art.)

*During my youth, there was a misunderstanding by critics and
those who "made" painting careers . . . In the abstract euphoria
of the day, I was accused of being a figurative painter because no
one could imagine that my painting could have any other purpose
than representation. In fact I was instructed early on by my acute
attention to ancient art. The great masters of sacred and religious
painting in the West and East are not only figurative . . . They
provide a vision beyond. The painting displaces the eye, which
turns inward, meditating and addressing the great spiritual
questions. [page. 215]*

Balthus's "day-dreaming angels" often gaze into mirrors, he
instructs us, not out of vanity, but in quest of spiritual knowledge;
Balthus's strangely stylized cats, with humanoid/demonic features,
prevail in numerous paintings as expressions of the inhuman and
ineffable, not unlike gargoyles on cathedrals.

Through the memoir, the elderly Balthus reiterates the prayer-
like nature of his painting. He describes himself as an "ardent
Catholic"—a "strict Catholic"—who has hung saints' images on
the walls of his room, including an icon of Our Lady of Często-
chowa given to him by a Polish cardinal; surprisingly, Balthus wasn't
born Catholic (he identifies his father as Protestant and says noth-
ing of his mother's background) but converted as a young man in
order to inherit a piece of property from a well-to-do Catholic rela-
tive. Medieval and early Renaissance Catholic iconography cer-
tainly had an influence on Balthus's paintings, of his "angels" in
particular. Yet there is no sense of Roman Catholicism otherwise

in Balthus's art; no suggestion of the Church's patriarchal hierar-
chy, its sacraments, and church rituals.

Of his young girls, Balthus declares:

> Some have claimed that my undressed young girls are erotic. I
> never painted them with that intent, which would have made
> them anecdotal, mere objects of gossips. I aimed at precisely the
> opposite, to surround them with a halo of silence and depth, as if
> creating vertigo around them. That's why I think of them as
> angels, beings from elsewhere, whether heaven, or another ideal
> place that suddenly opened and passed through time, leaving
> traces of wonderment, enchantment, or just as icons. [page 37]

In this way we are invited to see Balthus's disturbing paintings
as the very obverse of the iconoclastic, as we might have imagined
them; however boldly original Balthus's art strikes the eye, Balthus
seems not to have intended it as radical or discontinuous with the
painterly—"sacred"—tradition. Whether his daydreaming young
girls are wholly uneroticized, as Balthus recalls them, will continue
to be matter of dispute, for like all great artists, Balthus leaves the
viewer shaken and disoriented, not reassured. As his memoir is
something of a mythopoetic creation, an effort of self-defining and
self-invention, so his paintings are riddles to which we can supply
no answers; they are immensely beautiful and seductive dream
worlds of arrested time, as if European civilization fell into a trance
in the early decades of the twentieth century and never woke. (As
Balthus remarked in 1995, at the age of eighty-seven, his art repre-

sents the effort of a man seeking to escape the "chaos governing the end of the twentieth century." [page 237]) His most powerful work is of domestic scenes charged with mystery and strangeness, like the air before an electric storm, and where the painterly treatment is "primitive" and frescolike, in contrast to more realistic and polished, his art exerts its great appeal to the unconscious. (Compare the two very different treatments of an identical subject: the detailed *La Patience* of 1943 with the stylized *La Patience* of 1954–55.)

What is perhaps most valuable in this memoir is Balthus's depiction of his art as a process, not a product. The paintings are rituals requiring countless hours, days, weeks, and frequently years of rapt concentration; a slow, groping, intuitive process by which the artwork emerges out of a mysterious conjoining of the artist's highly informed conscious mind, steeped in the history of his predecessors, and the artist's imagination. We are most charmed by the memoir's ease of expression, as if Balthus were confiding in us, as individuals. We are brought into a startling intimacy with genius.

> *Although I've reached the point where I am given much praise, I feel without false modesty that most of my paintings are total failures . . . It's because I find so many things still lacking in them, unattainable yet foreshadowed. One day or another, they must be abandoned. [page 194]*

—JOYCE CAROL OATES

Vanished Splendors

A Memoir

I

One must learn to watch for the light; its change of direction, vanishing, and transitions. Start to learn about the light's condition in the morning, after breakfast and reading the mail. This is one way to know if you will paint today, if the progress into the painting's mystery will be intense. Also, if the light in the studio will be good for penetrating inside.

Nothing has changed at Rossinière. It's like a real village. I spent my whole childhood facing these Alps. Facing the mournful brown mass of Beatenberg's fir trees, against the snow's immaculate whiteness.

Basically, we came here because of my nostalgia for the mountains. Rossinière helps me to move forward, to paint.

That's what painting's about. I can almost say without exaggeration, that's all that it's about.

There's a kind of inherent peace here. Everything incites us to be silent: powerful peaks and weighty snow enveloping us in white heaviness; simple, friendly chalets placed on mountain pastures; jingling cowbells; a punctual little railway snaking along the mountainside.

So, let's check the state of the light. The coming day will help the painting advance, the one that has been in progress for so long. Perhaps a single touch of color, after long meditation in front of the canvas. Just that. And the hope of conquering the mystery.

2

The studio is a place for work. Indeed, for labor. It's a professional, essential place. I collect myself here, in this place of illumination. I recall Giacometti's studio. Magical, crowded with objects, materials, papers, and the general impression of being close to secrets. I feel much admiration, respect, and affection for Giacometti. He was a brother, a friend. That's why I keep a photograph of him here. I don't know who took it or where it comes from, but this way I work in Alberto's shadow, under his benevolent, meaningful gaze.

Today's painters must be told that everything plays out in the studio, in the fullness of time.

I love the hours spent looking at the canvas, meditating in front of it. Hours which are incomparable in their silence. In wintertime, the heavy stove snores. Familiar studio noises. The pigments mixed by Setsuko, the rubbing of brush on canvas, and everything returns to silence. The secret entry of forms onto the canvas is prepared, with barely sketched-in changes that topple the painting's subject into something vast and unknown. The tutelary image of the peaks appears through the studio's enormous win-

dow. From the Montecalvello castle that I own near Viterbo, at the back of the landscape, Monte Cimino can be seen with its path- ways through black fir trees, clutched to the mountainside. The same story unfolds both here and there, of power and mystery. Like a world receptive to its own darkness, where I know one must linger in order to attain them.

3

One must know how to tame and acclimatize time, to extract meaning from it. Arriving at a possible revelation through the time that is devoted to a canvas. To live in hope of finding it, with that frame of mind and attitude. My work is always done under the influence of spirituality. That's why I expect so much from prayer. It invites you to follow the right way. I am an ardent Catholic. Painting is a means of acceding to God's mystery, of extracting some radiance from His Kingdom, of making it possible to capture a shared light. This is not a vain desire. A humble one, rather. That's why I love Italy. When I first visited it as a young man of fifteen or seventeen, I immediately loved the country for the people's kindness and its tender landscapes. I've always considered Italy an enchanted land. Infused with spirit.

A painting greets our eyes from every window at Montecalvello. A painting is the same thing as a prayer: an innocence that is finally grasped, a moment torn from the disaster of passing time. It is immortality captured.

I have the reputation of taking perhaps a dozen years to complete a painting. I know when it's finished. That is, when it's

accomplished. When no further touch or trace of color will happen to correct a world that has finally been attained, a secret space finally perceived. So ends the plentiful prayer offered silently in the studio. So ends the silent contemplation. An idea of beauty has been reached.

4

I often insist on the necessity of prayer. To paint as one prays.
By doing so, to accede to silence and what is invisible in the world.
I am not sure of being followed or understood in this statement,
given that a majority of morons make so-called contemporary art,
artists who know nothing about painting. But that doesn't matter.
Painting has always taken care of itself. In order to reach it even
slightly, I'd say it must be ritually seized. To snatch what it can
offer as a form of grace. I must employ religious vocabulary as the
most apt and closest to what I mean. To join with what is essential
in this sacred world through a humble, modest availability that is
also presented as an offering.

Painting must always occur in this state of deprivation. Flee-
ing worldly currents, facilities, and vertigos. My life began in the
deepest poverty, with demands I had placed upon myself. I had
that sort of will. I recall my solitary days in the rue de Furstenberg
studio. I knew Picasso and Braque, and saw them often. They had
a great liking for me. For the atypical young man I was, different,
bohemian, and savage. Picasso paid me a visit. He told me: "You're
the only painter of your generation who interests me. The others

try to make Picassos. You never do." The studio was perched high on the sixth floor. You had to want to visit me. It was a strange place, where I lived far from the world, immersed in my own painting.

I think I've always lived that way. In the same existence, and yes, in the apparent bareness of today. I am stretched out on the meridional line, along the chalet's windows that receive the four o'clock sunlight. My eyesight does not always permit me to make out the landscape. The condition of light is enough to satisfy me. This snow-augmented transparency, a dazzling apparition. To retranscribe its passing.

5

By some mysterious analogy—surely a divine one—the landscape here, the Alpine peaks, and chalet, make me think of China. I discovered China while leafing through a book on painting. Its landscapes were obvious and familiar to me. When we bought the Rossinière chalet, after many joyous years laboring at the Villa Médicis in Rome,[1] my wife, Setsuko, and I knew that this place was made for us, that it was a point of juncture and unity between the landscape painting of China and Japan, and classical France. Around En-Haut, we rediscovered their way of appearing and disappearing, and the splendid, natural spontaneity that emanates from them.

I've always perceived a familiarity that ties me to Rossinière. There is something here allied with laws of universal harmony. A balance among masses, and above all, a fluidity of air and quality of light that renders everything more evident, with original clarity. That's why I love primitive paintings from Italy, China, and Japan. Their painting is sacred, with a responsibility to find the invisibility

1. Balthus was named by French Minister of Culture André Malraux (French writer, 1901–1976) to head the Villa Médicis, where winners of the Prix de Rome are housed.

and spiritual secrets behind appearances and visible forms. There is no difference between Piero della Francesca, for example, and a Far Eastern master. And no further difference between their landscapes and the one I see from my windows, the same haze that descends some evenings before nightfall, the same impetus to the sky, the same eternity.

But this elective frequentation dates back to childhood, when I illustrated a short story by a Chinese writer. Rilke, whom I lived near for a long time, was astonished by it, seeing in this choice a favorable portent, a predilection for a certain perspective, a singular way of seeing. Painting is only found in such crossings, in the passages between civilizations, in this metaphysical quest. Otherwise, there is no painting.

6

I retain a primary, fundamental, and innocent tenderness for Italy. Beyond the Italian landscape itself, what I love about her is that she has managed to preserve some primal unity, with the freshness of origins. I can also find this Italian aspect in a Chinese landscape, and rediscover the laws of universal harmony that a given Sienese primitive tried to represent.

I visited Italy during my youth. In 1915. My mother came to see me with Rilke. These are very strong, moving memories. Rilke knew how to be on terms of great familiarity with children. A secret spell united us. He received me at his property at Valais, with its virgin landscapes that resembled Poussin's canvases. No doubt that's where I acquired a predilection for the seventeenth-century master. I always try to pick up the scent of his knowledge of balance, to rediscover the mystery.

I found, once again, this charm in the landscape around Montecalvello. In this place, there is something akin to the quintessence of universal order between mountain and valley, woods and terraces, and the river that slips between the fields like a silver snake, between the château's proud severity and the pretty farm

dwellings below it. Everything rediscovered here has constantly governed my choices: Chinese painting, Italian primitives, and Bonnard too; they alleviate the geological rigor of this extraordinary site. The rock's fault lines mix with delicate pergolas and vine arbors in the manner of Far Eastern painters. Bonnard would have loved them.

But one must wait to attain this balance point in the landscape. I think that I was able to do so because of my openness, patience, and peasantlike poverty, which must be acquired, and without which one takes on false naïveté or artificial innocence, as Chagall did. Living before the Alps taught me that necessity. It placed me in a position to wait for this revelation, to experience the hope that it will free us.

7

I find this tragedy less painful to absorb when it is experienced in the context of religion. I repeat, I am a very strict Catholic. Saints' images surround me in my room, including an icon of Our Lady of Częstochowa that a Polish cardinal gave me, hanging directly in front of my bed. She watches over me and protects me.

Last February, an odd thing happened to me. I didn't feel well. Setsuko was eating dinner below with Harumi. My faithful Liu hurried downstairs:

"Would you please come?" he asked them. "The Count is feeling ill."

Setsuko guessed that something serious was happening. Liu's typical calm and reassuring presence radiated an unusual tension. Setsuko went up to my room and found me motionless, not asleep or unconscious—my eyelids trembled—but unable to open my eyes. Later, the Countess, who was the direct witness at the time, recounted everything.

"Balthus! Balthus!" she called out.

I didn't respond. I was elsewhere. She measured my heartbeat, which was normal, and my pulse was calm. She waited for a

moment and then called me again. No answer. It seemed as if I was unconcerned by the disturbance happening all around me. A half hour later, a doctor was called. Setsuko was tormented by worry, and told me later that she experienced a strange feeling of both fear and calmness, as if something supernatural were happening. After forty minutes, I finally opened my eyes. My glance was normal and lucid, and I declared straight off:

"I just spoke with God. God summoned me to His side. He told me that I still have lots to do in my life, which is not yet over. God told me to continue working, and I must listen to God."

A dazzling, blinding light shone in my eyes, an inexplicable and untranslatable gleam of which I was unaware.

It was a magnificent moment, and I still hear the voice that told me: "You still have lots to do, and when the time comes, I'll call you back to Me." From this time on, I've had a sort of light within me. I've had major physical problems, trouble walking, and bouts of bronchitis because winters here in the valley are harsh and humid. And lately I've lost confidence, as my eyes and hands play tricks on me. But the light which I saw totally, in its plenitude, was surely there to brighten the worrisome path. And that gave me even stronger belief. To continue to follow God's path.

8

Each morning, I check the condition of the light. I only paint by natural light which changes with the motion of the sky, undulating like moiré and organizing the painting. I never paint by electric light.

I always begin a painting with a prayer, a ritual act that gives me a means to get across, to transcend myself. I firmly believe that painting is a way of prayer, a means of access to God.

Sometimes I've been reduced to tears, facing the challenges of a painting. Then I hear a godly voice speaking to me from within: "Hold on, resist!" It's a certain kind of grace, as in the libretto of Mozart's *Magic Flute*. These words, whenever I hear them, make me continue with my work. Follow the path until life is over.

As I age, I feel less sure of myself than before. Often I even ask myself if I shouldn't give up painting, because I find that it isn't as good as what I did in the past. But I can't bring myself to do it.

9

Painting is both an interior necessity and a skill. One never repeats too often that the wanderings of contemporary painting happen because of lack of labor, and necessary silence. Painting is a lengthy process that consists of making each color, like making a note of music, connect to other colors, or collectively producing the right chord. Colors only exist in relation to other ones. As in music, if you sound a note, for example G or G minor, everything changes accordingly. As soon as another color is present, the composition is altered. Once again, a color only takes on its role, or one might say its timbre, when another one is beside it.

I picked up this knowledge through slow work in the studio. Now I find colors and nuances fairly rapidly. This is so, even though my vision has considerably weakened. What miracle or grace has been given me so that I see well when I paint?

Often the Countess acts as studio assistant, executing very subtle blends of color that almost always intrigue me. Mostly, they are drawn from our constant mentor Delacroix's formulas. And the painting unfolds slowly, day after day, in the peace of Rossinière.

Sometimes, before starting to paint, I stand for a long time in front of the canvas, meditating, trying to live inside it. A long familiarity is acquired, sometimes with imperceptible changes. The Countess sometimes fears that I might rub it all out and start the painting over again. It's an unpredictable labor that winds up as a secret connivance, a mysterious encounter.

Painting has taught me to reject time's frenetic wheel. Painting lives outside time. I am trying to attain the secret of painting's quietude.

10

No one thinks about what painting really is, a skill like that of a laborer or farmer. It's like making a hole in the ground. A certain physical effort is needed in relation to the goal one sets for oneself. It is a discernment of secrets and illegible, deep, and distant paths that are timeless.

In this sense, modern painting has failed. I knew Mondrian well, and miss what he depicted early on, some fine trees for example. He looked at nature and knew how to paint it. And then one day he fell into abstraction. On a lovely day toward evening, when the light was barely starting to fade, I went to see him with Giacometti. Alberto and I looked at the magnificence happening outside the window, a setting of twilight glow. Mondrian pulled the shades, saying he didn't want to see it anymore. I always regretted his transformation and upheaval.

Later compositions of modern art were assembled by pseudo-intellectuals who neglected nature, and became blind to it. That's why I always fiercely relied on my own resources and the notion that painting is, above all, a technique, like sawing wood, or making a hole somewhere, in a wall or the ground.

II

The same is true of modern poetry. I understand nothing about it, although I've known some great poets. For example René Char,[2] who was a hero and intimate friend. I saw him often until the end of his life. I still recall how Princess Gaetani, from whom I rented an apartment, also fell under René Char's charm and asked me to leave so that he could move in. Char liked me a lot, and inscribed two or three collections of short poems to me. But I didn't understand all his passion and fury. One day he asserted that he almost shot Tristan Tzara because of the terror he inspired in the literary world.

I've always preferred the limpidity of great classical texts to modern poetry. Like Pascal, and above all Rousseau, whose *Confessions* have remained my sole bedside reading. In them I found the clarity and simplicity of language that one finds in great classical painting, the diamondlike transparency also visible in Poussin.

2. René Char (1907–1988), French poet.

The idea of painting as I always conceived it, as stated above, has completely disappeared. Poetry has followed the same path, becoming intellectual, obscure, and hermetic. The clarity perceptible in Mozart, which Rilke sought, an obviousness, has been abandoned.

12

My memory of the century I have lived through and the people I've met remains intact, but it isn't chronological. Rather, it is analogical, with one event and anecdote linked to another, weaving my life's canvas. I've often thought that the best value and finest virtue was in keeping quiet and creating silence. I never interpreted my paintings or sought to understand what they might mean. Anyway, must they necessarily mean something? That's why I so rarely discuss my life, finding it useless to describe it.

Rather than expressing myself, I've busied myself with expressing the world through painting. Besides, the moments of my life are drowned in memories of wartime; so many things almost killed me that there is something derisory and aleatory about chronicling one's life in a well-designed way. It's almost presumptuous.

My life's progress might have been immediately interrupted when I nearly stepped on a land mine in the Sarreland. One thing or another always draws me back to wartime events. For example, my current inability to walk unaided reminds me of when I was wounded long ago. In the end, I see it all with a kind of indiffer-

ence. I no longer feel any impatience or exasperation. So be it. One necessarily acquires a kind of wisdom and interior peace that old age brings.

At the same time, I am fairly indifferent to my paintings being sprayed throughout the world. My work, my oeuvre, everything, is out in the world. The Countess buys my paintings when she can, such as my first painted landscapes, or a portrait of Colette that is in the sitting room. It's touching, just like her determination to create a Balthus Foundation. She struggles, telling me, "If you let it go, I will continue by myself." I know she is right. I'm touched by the Swiss government's desire to start a foundation project here at Rossinière, in an outbuilding of Grand Chalet. It's a way of collecting what is dispersed. Collecting, linking, and preventing a massive dilution.

13

Surely some places and people are made for us. They cross our paths and become indispensable, almost by fate. Such was Rossinière. When I had to leave the Villa Médicis, Setsuko and I looked for a suitable place to live together. We had traveled in the En-Haut region and stayed at Grand Chalet, which later became our home. It was an inn that in years past had hosted Victor Hugo, and, it was said, even Goethe and Voltaire. Right off we were seduced by the discreet, sober, and intimate charm of this magnificent home, although it was run-down, badly maintained, and too large, with its dozens of rooms and hundred windows. Yet something told us that this place already belonged to us. Setsuko unconsciously appropriated it, as it made her think of an ancient temple of northern China or imperial Japan. Shored up against the mountainside, the Montecalvello château, as mysterious and profound as paintings of temples suspended in the void, invited us into the very heart of nature.

But something extra prevailed at Rossinière, a grace, gentleness, and peace diffused by the golden blond deal covering the walls and floors, that creaked with every step. The owner, surely

tired of maintaining such a vast home, casually told us the chalet was for sale. We weren't even surprised to hear it, as we already believed ourselves at home.

Thanks to an arrangement with Pierre Matisse, we were able to buy the chalet. I gave him some of my paintings and he bought the old house for us. In 1977, we moved in after a lot of work was done on it. I was able to do that, as in Rome I became a real specialist in home restoration.

I sought to restore Grand Chalet to its previous proud beauty, with the charm of a farmer's house. We retained some furniture already at the inn—a blue ceramic stove like the ones in Vermeer's canvases and some slant-top secretaries of unfinished deal in the Gustavian style. Setsuko did the rest. Harumi, who was barely five years old, enjoyed it enormously. Today she still feels at home here, in the land of her childhood. She went to school with the little children of Rossinière, playing with them on the icy paths and riding on horseback at the Château d'Oex stables. She still goes back there, spending entire mornings galloping through the fields at the forest's edge.

Though I spend most of my time at Rossinière, I still haven't painted the Alpine foothills of the Vaudoise that I've known since childhood and loved so. I've often painted Montecalvello, the Tiber valley, and Chassy, but why not Rossinière? I have always wanted to do something with the Rossinière railway station, a small building that hugs the mountain, through which a little train, the Mob, which Setsuko sponsors, goes at regular times. There is a rack railway that snakes along from Lausanne like a childhood memory kept intact, and this landscape I still haven't painted.

14

I'd like to mention the happiness of having Harumi at Rossinière. Her name in Japanese means "spring flower." She was born in Rome, in the replenished splendor of the Villa Médicis, which I contributed to in some small way. I recall that she was fascinated by official evening parties, and grew up with ease amid Roman high society that crowded the villa. At the contemporary music concerts, which I disliked but had to attend until I made myself scarce by claiming work as a pretext, she sat in the front row with a nanny, watching the performances. She had a poetic, free childhood in Rome, and often loved to sleep in the famous Turkish bedroom which I'd had restored as decorated by a former resident, Horace Vernet.

She's an extraordinary person from every point of view, and fiercely independent. I will always recall the emotion I felt when she was born, and they telephoned me at the Villa to tell me that I had a little girl. I immediately went to buy her a piece of furniture that has remained in its place since then. It's difficult to describe her, because she is infinitely complex. She always says what she thinks, with great impertinence, or one might say, totally disarm-

ing innocence. I find she resembles me greatly, above all when I was young; she has a royal, youthful poise, a certainty about pursuing her own way, confidence in herself and her powers. Just like I did when I painted against all other currents.

But in some ways she is more solid than I am. In aging, I may have lost a sort of savage willpower that Harumi possesses today. These days I feel more calm and sentimental. I'd say that the story of my houses is akin to the "feudal" spirit and character that dazzled me at Montecalvello, where the atmosphere often reminded me of Stendhal.

Harumi decorated her apartment on the château's top floor, with a terrace around it. From there, she oversees the entire valley. She's very inventive, and some years ago she started her own label, designing jewelry made of trimmings and semiprecious stones. She also designed "Balthus bags" made from my studio aprons, on which I wipe my brushes. She also decided to make her own perfume: "Harumi by Harumi."

She did all of this on her own initiative. She never liked school, being a little rebellious. She describes herself as "a perfect dunce." But I've always loved her individual freedom, the way she taught herself just as I did when I decided to follow my own path away from any school. Following Bonnard's advice, I went to copy the classical masters and Italian primitives in Paris and Tuscany.

15

That's why I love the untamed grace of cats, and why I've often placed them at the heart of my paintings. I've always had a special, elective relationship with them. Starting in childhood, my little pals called me "the boy with cats."

My life was situated under their sign, in a way. At age six, I drew a series of India-ink pictures telling the story of Mitsou, a little cat I'd lost and whose loss left me inconsolable. It was composed as a sort of wordless comic strip, but very expressive. A little epic was recounted, from adoption to disappearance.

Mitsou was rebellious and never missed an opportunity to run away. His last escape was definitive: I never saw him again. Painting Mitsou's story was a way to make our friendship eternal, a means of preserving the moment. Wasn't that already art in a succinct format? I drew different parts of my life with him: in the train; with my mother; in our house; on the stairway; in the kitchen and garden. I drew myself holding out a ball of string that he tried to grab; there was Mitsou shooed from the table because he stole a bit of bread; Mitsou in bed with me, curled up under eiderdown quilts; Mitsou admiring the lit-up Christmas tree with the whole family.

Then the drawings became more refined to make room for grief. I depicted myself looking everywhere for Mitsou, in the cellar and deserted streets, and the last image showed me weeping large black tears.

Rilke, who was then a great friend of the family, encouraged me in the project and attentively followed all its stages. He finally decided to publish the drawings with his own preface. The collection was published in Germany in 1920.

Very early on, I understood that I secretly and mysteriously belonged to the world of cats. I felt the same desire as they did for independence, and as Rilke said, the final impossibility of knowing a cat's true nature. He wrote, "Was man ever their contemporary?"

I don't ever recall being exiled from their presence. They've always surrounded me, and one day someone told me that I give off a strong musky odor that attracts them. I recall above all Frightener, who as his name indicates was truly terrifying. Other cats disappeared whenever he arrived. Though very nasty, he was a superb tom and followed me everywhere, gentle as a lamb. I recall docile walks he took with me, whereas he flew into rages under other circumstances. In 1935, I portrayed him in one of my paintings, *King of the Cats*. In it, Frightener rubs against me, seeming very nice, but his expression reflects something ferocious. I feel that I also have a fierce manner, and resemble him a little.

In the 1950s, when I lived in the Château de Chassy in the Morvan region, I had as many as thirty cats. It was an enormous building with weighty foundations, and there was plenty of room, with outbuildings for animals.

One day in Rome, I found a little cat in the Villa Médicis gardens. He seemed completely inoffensive, but caused an incredible mess at Chassy by turning out to be tyrannical and nasty. He never let any of the other cats eat, and fought with all of them.

Yes, cats are a constant presence in my work. They are like discreet, silent presences who accompany me through life, never disturbing it. A young girl whom I knew in the Artaud days and whose name was Miss Sheila, if I recall correctly, always called me "King of the Cats." I painted her portrait: *The Princess of Cats*. It's the only painting with this title.

I like to think I really am their king. Incidentally, I have an unmistakable marking: in my left eye there is a network of small indelible red veins in the distinct form of the number thirteen. The resemblance to these two digits is very much in the Balthus style! The room I sleep in at Grand Chalet retains its number from the former inn, which is thirteen. I thereby incontestably decree myself to be the thirteenth King of the Cats and I establish this dynasty with certainty!

Here at Rossinière, the cats have an ideal life. They have daily contact with us, participate in our meals, sneak in during our ritual teatime, and sleep on cushions that depict them, embroidered by the Countess. They listen to Mozart with me while I doze beneath the wide sitting-room windows that let in the afternoon sun's golden brightness. Certainly they must know the score of *Così fan tutte* by heart.

16

Not a day without Mozart, his gravity and grace. What I admire most about him is the deliberation and haste with which he puts everything into a score simultaneously. He retains a lightness and subtle religiousness. Every single day I stretch out in the sitting room and meditate, relishing *Figaro*, *Così*, or *The Flute*. I rate Mozart above all other composers in the whole world; he attained the universal, the most elevated expression of the human spirit, and he knew better than anyone how to stir the emotions, thereby reaching earthly secrets, and the deepest buried mysteries. He has always been my model, someone who helped me see the essence of things. Painting and music merge, both speaking about the same things, seeking to reach the same vibration. I've always wanted to attain this degree of perfection, and neither Bach, whom I admire, nor Beethoven, has transported me as far as Mozart.

In painting, one can achieve something infinitely sacred, which Mozart managed to do in music. This explains the joy I felt in 1950, working on stage sets for *Così fan tutte* for the Aix-en-Provence opera festival. There, I sought to re-create Mozart's fluid grace as well as the poignant pain and heartbreak hidden behind a

mask of apparent gaiety. Before starting on the sets, I literally immersed myself in the score. I still know it by heart, and always feel the emotions I experienced while working on the project all those years ago. Endlessly replaying Mozart CDs renews the past, and the joy in which I lived. It takes me back to a time full of electricity and liveliness.

Pierre-Jean Jouve, who also wrote about the staging of Così, aptly describes Mozart's intent to transcribe the world's cruel reality: "the marriage of pleasure and sorrow . . . Musically, a heady essence." This, I tried to interpret as well.

In fact, Mozart tells man's entire history, both intimacy and grandeur. He did so by striking the precise note with an almost disarming simplicity. It is an art of offering unadorned lyrical song to the world, so knowledgeable and powerful that it cannot be seen. This kind of simplicity must be attained in painting; I've always told myself that proximity to all men and universality are essential in painting. When I take a rest while listening to Mozart, I feel an entire gamut of emotions, like that of colors: humorous, plaintive, unhappy, joyful, tender, compassionate, and painful. He tapped a universal, gigantic reservoir. I've often modestly aspired to dip into the same well, without abandoning my beliefs.

17

This notion of painting has guided my whole life from earliest childhood. Rilke discussed faith with me indirectly, through poetry, and it was surely there that I discovered how spirituality must be sought and uncovered in its vast splendor amid the poverty of worldly things. Bonnard understood this. You can see it in his floral bouquets; the earth barely covered by hoarfrost; winter landscapes; and the sun-filled balconies he painted so precisely. Some have claimed that my undressed young girls are erotic. I never painted them with that intent, which would have made them anecdotal, mere objects of gossips. I aimed at precisely the opposite, to surround them with a halo of silence and depth, as if creating vertigo around them. That's why I think of them as angels, beings from elsewhere, whether heaven, or another ideal place that suddenly opened and passed through time, leaving traces of wonderment, enchantment, or just as icons.

Only once did I paint a picture as a means of provocation, in 1934, when the Galerie Pierre displayed my paintings *Alice*, *The Street*, and *Cathy's Washing and Dressing*. Behind a curtain was *The*

Guitar Lesson, judged "too daring" at a time when Cubist and Surrealist frenzies offered their provocations.

At the time of *The Guitar Lesson,* I still lived on rue de Furstenberg, little concerned with comfort or material needs, but entirely attached to understanding painting and its mysteries. Shortly afterward, I left my studio for the courtyard of the Hôtel de Rohan, also in the Saint-Germain-des-Prés quarter. It was a vast studio in grandiose disrepair that managed to preserve its past glory, a sort of majesty, an almost epic power, religious in the old sense of the term. In this decayed universe whose abstruse powers I sensed, the only thing that interested me was the labor of painting. I was twenty-six years old.

18

I learned to work like this very early. Starting in childhood, my mother, Baladine, liked to say that I copied painters, especially Poussin, with scrupulous tenacity. I claimed this was the best school for me. In a letter to Rilke, she stated that Maurice Denis was very indulgent and attentive to me: "All he lacks is equipment and expertise," he said. I quickly buckled down to an apprenticeship in the copyist's school. In my youth, I was able to make progress, thanks to the expertise and generosity of the great talents I encountered. By remaining modest, I was able to learn from them.

I never attended classes in any school. At age sixteen, I lived in Paris, where my parents sent me to study painting. I frequented the creative people they knew well—Bonnard, Gide, Marquet—who witnessed my brother Pierre's and my own explorations. At the start of the 1920s, Paris experienced intense artistic activity and spurred creativity. Bonnard comforted and supervised me, and introduced me to the art world, showing my work to the dealer Drouet, for example. In 1925, I believe, I painted a series about the Luxembourg Gardens: children along the walkways, and the powerful presence of solid, omnipotent trees. At the time I was very

interested in carefully rendering material effects, the weight of objects, their gravity.

When I was young, I accorded importance to color, the very material of painting: pigments, oils, everything that gives presence and life to the world's matteness and solidity.

At the time I was very open to the experiences of others and attentive to everything Bonnard and Maurice Denis said. I never rebelled against their abundant advice. Surely I learned from them that painting is an art of patience, a long story with the canvas, an engagement with it. Now, in my studio in Rossinière, I can be satisfied with the progress and advancement of a canvas only if I meditate in front of the unfinished work. With one gesture, I add a single touch. This is slow art, in which the work continues, nonetheless. The haste of contemporary painters is atrocious insofar as it rejects the necessary craftsmanship that painting requires from those dedicated to it. Nothing can be done without a slow movement of the mind in unadorned humility, which one must retain.

In the years 1925–1926, my habit of spending days at the Louvre copying Poussin led me into the adventure of painting. There I learned, better than in any school or academy, Boileau's advice: "Return to work a hundred times on your craft."

My advances were made in solitude, a solitude that was of course aided by the advice of masters who believed in me, and also my mother, who had great confidence in me. At age nine or ten, I drew soldiers in tight ranks, penciled scenes from the life of the Marquis de Montcalm. At age thirteen, I sculpted little effigies, including an identical copy of a Buddha that Rilke had given my

mother. Now, these years of training—"the uncertain years," as Rilke called them, of war, flight, exiles, and pogroms—still retain the most emotion for me. These were years of "enthusiasm and fervor," as Gide called them.

During our stay in Beatenberg, I threw myself into a project of making vast compositions for our village chapel. I don't know what became of those paintings; it's as if they vanished into thin air. Inspired by Dante, I came up with religious iconography of my own, painting scenes from the Old Testament, one with Sarah frightened by the arrival of the angel Gabriel. Rilke had given me a copy of *The Divine Comedy*, and I was transported by Dante's imaginative power and forceful visions. The fashion for bare walls that came later must have banished them. I regret that all this work disappeared. Yet I retain a distinct and nearly complete memory of it, as well as my enthusiasm and youthful fervor.

19

I also associate my youth with a stay in Kenitra, Morocco. I did my army service there from the end of 1930 to the beginning of 1932. In old age, memories suddenly resurface from oblivion, but in a different light. What seemed to me right after my return from Africa as a time marked by boredom and creative inactivity has become illuminated, and the images now seem dazzling. I recall with appreciation the natives' noble faces and manners, and above all the brilliant landscapes that moved me deeply. Thanks to a member of the Vogüé family who knew my father well, I was able to join the Seventh Spahi Regiment. Before that, I was assigned to an African infantry regiment.[3]

My regiment was essentially quite snobby. For a long time, even after leaving Morocco, I wore an ornate, handsome uniform. Then I thought that this might seem pretentious, so I folded it up and kept it in a closet. Over time, it became moth-eaten. So much for memories.

I made friends with a garrison captain and together we traveled a good deal in Morocco's Atlas region. It was a way to escape

3. The Vogüé family were French nobles with a tradition of army service dating from the Napoleonic campaigns.

a regimented garrison life and monotonous days under an oppres-
sive sun. That's how I discovered not just the south with its palm
groves but also the royal cities of Fez and Marrakesh.

I loved the jagged and fierce landscapes, brilliant light, and sav-
age colors that formed a palette so admired by one of my masters,
Delacroix. Thanks to my army service, I rediscovered all of
Delacroix, and my esteem for the great painter was totally rekin-
dled. His travel sketchbook remains among my all-time preferred
bedside reading. Even today, it helps me choose colors, tricks of
the trade. It's a skill I value a great deal, a skill the modern world so
easily forgets.

I was struck by the almost balletic side of military life, the
strictly organized marching, the regular exercises. In the few paint-
ings I made during this period, *The Spahi and His Horse*, for exam-
ple, or *The Barracks*, I believe I showed this type of choreography
that seemed obvious to me. In a Spahi regiment, horses play an
important role. I became attached to one regimental horse. When
my army service was finished, he let himself die. I learned about his
death when I was living at rue de Furstenberg. I felt deeply sad, and
still retain a trace of this feeling here at Rossinière.

This period was, I might say, premonitory and preparatory for
my painting. It always seemed to me that from then on, my paint-
ing would proceed along its true path. It is as if everything that
occurred during my required stay in Morocco had matured my
work, accorded it true meaning. Yet I was hardly productive during
these months spent in North Africa. My work was limited to a few
sketches and two or three canvases. But painting is a complete

activity, which takes all of one's time, and when one isn't actually painting, one still paints anyway. That's what happened during this period. And that's why when I returned to France, I knew what I really wanted to do. So, there was no interruption because of Morocco; on the contrary, it provided a link in a coherent and logical continuity. Ramuz[4] embellished the story about my army service, thanks to his power of imagination. He did ask me one day how my time was spent, and I told him about the horse and the friendship that formed between us, and he just made up the rest.

4. Charles Ferdinand Ramuz (1878–1947), Swiss novelist and poet.

20

Here at the Grand Chalet, horses continue to be a part of my life. My daughter, Harumi, had a stable built on a little piece of land contiguous to the chalet, with doors in the style of flea-market art and stalls that resemble rooms. It also slightly resembles the wooden huts found near Zakopane, Poland, which pleased this old Pole from the Tatra mountains. Harumi often goes up to the Château d'Oex stable, located above Rossinière. One day, the owner of the stable invited us to take a ride in a wedding carriage pulled by a two-horse team. We took a long tour through enchanting landscapes, as far as Gstaad. Steep roads and grand mountains surrounded us and they were immensely beautiful. We passed villages that looked like children's toys. Such pleasant and joyful moments remain in our lives permanently: I realize that there is no going back from the automobile—our poor world cannot eliminate it—but look what it has done to Rome's center. It has become a permanent traffic jam with noise and pollution.

I knew the Eternal City just before it was invaded by the automobile. It gave off an indescribable charm, a unique grace. Then the 1980s toppled it into brouhaha and tumult. Like a metaphor of

modern life, which my friend Fellini predicted in his fine film *Fellini-Roma*.

That's why I was often drawn to places that I intuitively felt were solely meant for me. Others wouldn't want them on account of their unusual location, extreme disrepair, or excessive size. I felt myself subconsciously being called to them. In them, I found temporary refuge from the world's erosion and pollution.

I am fully aware that Rossinière is home for me, where birds sing and a kind of gentleness that pacifies everything, even old age, abounds. I am indifferent to its infirmities, and accept this condition as a natural prolongation that favors painting and prayer. All I need to attain a form of happiness is a studio and the slow development of a canvas on an easel, finding the most adequate combination of colors while grinding pigments with Setsuko. She helps me to obtain the colors, as she has an exceptional feeling for color. Her own painting, which I greatly admire, proves this.

Harmony is true richness. Beauty and Richness, that's what I always wanted to attain with my painting. Through them I could reach the divine. There is something of it in the silence that reigns at Grand Chalet despite our presence, the burst of Mozart across the rooms, and our steps that make the wooden floors creak. A sort of sweetness has finally been attained or discovered.

I've always had a landowner side and feel that living here is like a permanent reconciliation. Painting and landscape blend with each other, and every day from our window, I have a real painting before my eyes. My life merges with Rossinière's simplicity and landscape. I have no real life to write about, only scraps of memory

which, when connected, create a woven version of myself. The man and his painting are one and the same, and my only real statement is through painting. I've known too many writers to have the gall to aspire to literary pretension: Camus, Saint-Exupéry, Char, Jouve, and so many others (except Green[5], whom I missed!). They sought a few heterogeneous and yet homogeneous words to protect them from time's erosion.

5. Julien Green (1900–1998), American-born French novelist.

21

Each day that God gives us, I pray and meditate silently. This predisposition is essential to paint and escape from the world's calamities, its uncontrolled motion, and expensive noise. The rosary given to me by the Holy Father helps me greatly in this internal effort. I met John Paul II during my stay in Rome. He was then in his prime, and made a great impression. He was disappointed that I couldn't speak Polish, having joyously anticipated a talk with a compatriot. Alas, the conversation had to take place in French. But he knew how to put people at ease, not giving umbrage to anyone. I believe that God in His goodness decided to send a saint to our miserable world to try to revive in mankind a spark of intelligence and love. Yes, I'm convinced that God felt the need to send a saint to the earth. My belief was reinforced by his own belief, by his certainty and the fierceness with which he communicated it. I love impetuous, fiery, and mystical personalities. In a sense, Artaud had this mystical fierceness. At one time he wrote me letters in a believer's voice, speaking with quasi-religious fervor of Saint

John the Baptist and Saint Francis of Assisi. I often told him that he chose the wrong path in playing Surrealist games: "Beware of them," I told him. "Beware of them." He replied: "I know exactly what they are doing," but he didn't have the time or energy to recover. I am certain that he could have been a great mystical artist.

My great energy comes from my faith, which allows me to advance with a tenacity that was always recognized, even at a time when my painting was not. I have an untamed spirit, which I had at the outset. I've worked, so to speak, with Masaccio, Piero della Francesca, and Fra Angelico, who as his name indicates is close to the angels, and a little-known painter from central Italy, Masolino da Panicale.[6] Their exactitude and extensive work, not always recompensed—Masaccio died so young— inspired me with fiery energy and convinced me to pursue my vocation. I recall the lengthy time spent with them during my bohemian years in Tuscany, when part of the day was devoted to odd jobs for subsistence—I worked as a trattoria busboy and tourist guide—and during the hours of rest, I would go to rediscover them. I urgently wanted to copy them, to get as close as possible to them, to discover the secrets of their color. I spent whole afternoons before Piero della Francesca's frescoes in Arezzo's San Francesco church. No one knew the neglected painter then, and only now has his genius been discovered through scholarly works, art books, and exhibits. To be alone

6. Masolino da Panicale (1383–1447), Florentine painter.

with his work was almost surreal; I was plunged into the heart of painting, the heart of what I knew obscurely was the most brilliant painting. It was like uncovering the world's most sought-after secret.

My youthful years passed in these constant solitary initiations. Since then, I've kept a taste for solitude, the desire to enter alone into the mysteries of painting and fathom its depths.

22

The revelation of a painting's obscure mysteries is slow and aleatory. One of my most recent paintings, which I sent to the National Gallery, the composition of which was inspired by a Poussin work, underwent a patient development on its own, without my being aware of it. A painting's different stages betray the painter's endless trial and error as he tries to arrive at what he feels is the definitive, final, completed state. It depicted a nymph surprised by a satyr. It took a long time before I was able to bring her naked body outside, into the open air. Everything went wrong with the composition. At a certain moment, I covered everything with Pozzoli red paint to start over from scratch. Then, quite "naturally," if I dare say so, the nude found her place on a stone divan, and I suddenly discovered that the open-air nude's light spontaneously led to moonlight. Setsuko drew a crescent in chalk at the top of the painting. And it gradually proved its own inevitability. With the pearly body irradiated by the moon and vice versa, everything became coherent and took on meaning. The landscape in which the body was enthroned was established for eternity, right down to the little crown of pinks included in the canvas as a mem-

ory of Du Bellay's poem: "I offer these roses, just blooming . . ." and also Poussin's floral nymphs. The pinks refer to summer, and the whole canvas became a summery painting that deserved its title, *A Midsummer Night's Dream*.

My paintings are composed and organized by this indecisive and nocturnal approach. I give no tyrannical orders, but let the painting make itself. The hand receives indications and serves as a humble and faithful tool for beauty to realize itself.

23

After the studio work, let's return to Grand Chalet. At 4:30 or 5 P.M. in summer, Setsuko orders the preparation of a traditional tea. The unchangeable ritual finds us in the dining room for something reassuring and peaceful, enviable in a rushed and agitated world. Another familiar element is the whistling by Mob, the little train from Lausanne that slowly climbs the mountain, whistling along its narrow tracks before entering a tunnel at the back of the valley. It regularly marks the hours and the time that inexorably flows by. Setsuko had to complete a lengthy series of improvements for our home to find its point of equilibrium and silence. When we came here for the first time, Grand Chalet was still an inn, and everything was dirty and nearly abandoned. The tea we were served was so bad—it tasted like chicken stock—that we surreptitiously threw it out the window.

Now Setsuko prepares teas, exquisite jams, fruitcake, and chocolate tarts; this moment of pause in the slow life at Grand Chalet also makes up part of the painting. As cats climb on the table, and brush by the teapot to warm themselves without knocking it over, we talk about pictures, of painting and canvases in

progress. More and more, I prefer to stay at Rossinière, as the trips to Montecalvello have become a lengthy affair. We still do go there once in a while, but do not remain for long. Soon I miss the chalet's sweet tranquillity and ordered life. When the weather and light conditions permit, I go to the studio, led by my faithful Liu, who never leaves me; he sets me in front of the unfinished work, and sometimes I stay there silently for long moments, smoking a cigarette, looking at the canvas, meditating in front of it. This preparation time is indispensable before the painting can be entered into, rejoined.

24

I fully understand that all this sweetness and grace is prepared for me by Setsuko, the dearest person on earth to me, who watches over me, attentive to the least weakness or blunder of a man who can no longer see or walk well, and needs help to get up to his room and flick his cigarette ash into the ashtray.

I met her in Japan in 1962. Malraux had sent me there to prepare an exhibit of old Japanese art. Setsuko Ideta was a young student who then lived with her aunt in Osaka. She came from an ancient samurai family that preserved the rites and nobility of old Japan. I invited her to come to the Villa Médicis, where I'd been director since 1961. All of a sudden I realized that she meant a lot to me, and we were married in 1967. We are always together; she preserves my work, protects me from disturbances, advises me and does innumerable things for my creativity, organizing our archives, patiently mixing colors that I ask her for—a thankless job requiring patience that she always performs cheerfully—and in short, she ensures my well-being. She neglects her own work as a painter, which I've always encouraged. The interior scenes in

our chalet that she painted are admirable, with all the colors of her native Japan.

Thanks to her, I became more interested in Japanese and Chinese culture: their vigor, powerful lines in paintings, and hieratic nobility. The violent separation between Western and Eastern civilizations during the Renaissance was arbitrary and harmful. I deeply believe in the ties that unite them, and I see scarcely any difference in their interpretation of the world's meaning. Therefore there's no difference between my beloved painters from Siena and Far Eastern art. Setsuko reassured me in this certainty. She ties me to both civilizations, thereby assuring the link I always believed in, long before I met her. And she feels at home in the high altitude of Vaud, where we live. The tall mountains surrounding us are familiar to her, even though she is not drawn to them, preferring flatter lands. But she brings traces of her country to the chalet: the traditional garments she wears, the Japanese food we often eat, her collection of figurines, marionettes, and mechanical dolls, not to mention the chalet's carved facades, which from far away resemble a Far Eastern temple.

25

I can date my fascination with the Far East to my early youth. At around age thirteen, I grabbed hold of a Buddha that Rilke had given my mother. I refused to give it back and resolved to make a copy of it. My mother, Baladine, said that I held it to myself like a cat, from fear that she'd take it back. I also launched a large project to write a play about the Eastern civilization Rilke referred to in a letter he sent me. In Beatenberg, this fascination took shape as I spent time at the window watching the snow fall; I loved untamed nature, steep and sheer slopes, dramatic ravines, and white peaks. Around age fourteen, I discovered the southern Sung mountains in a book on Chinese painting. It was like a revelation, or rather a discovery, a recognition that this was indeed my place and there was no separation between the Alps before my eyes and the dizzy-ing peaks of eternal China. This love of landscape remained with me always. I rediscovered it here in Rossinière, in a way that makes me feel I have never parted with it since childhood. I don't try to paint a reproduction of nature, but signs of a universal community and identification of a thought and deep meaning, at the same time coherent and obscurely mysterious. The landscapes I painted at

Montecalvello resemble those captured by Sung painters, and I do not try to render my vision of them in a more Chinese or Japanese perspective. They are spontaneously linked to Far Eastern land-scapes, as if part of the same search for unity.

I believe that there are many misunderstandings about some nineteenth-century French painters generally considered to be realists. A painter like Courbet, whom I greatly admire, rejected the massive separation from Eastern art that the Renaissance fur-thered. Courbet painted as did the Chinese, my beloved Sienese, and Brueghel. Indian art, which inspired me, and medieval art are not strictly representational either. The painter and sculptor iden-tified with their models, and entered within to find meaning. Paint-ing, thus, may be understood as a spiritual art that reaches godliness.

Although the Chassy landscapes I painted are different from those of Montecalvello, they also express the same "philosophy" of painting. They go toward this meaning and the silence for which I am striving.

26

Painting can provide some moments of inexpressible joy. Nineteen-forty, when I painted *The Cherry Tree*, was a tragic year when history descended into total disaster. Even so, I painted *The Cherry Tree* in the little village of Champrovent in the Savoy region. I lived there with my wife, Antoinette de Wattewille, after I was wounded in the Sarreland and demobilized. This allowed me the opportunity not to be permeated by the drama going on in Europe.

I tried to isolate Champrovent from the black canvas I feared would gradually cover Europe. I therefore rejected somber or deadly premonitions. To paint *The Cherry Tree* was to paint a remnant of joy, to encapsulate it before it vanished. Dazzling light on trees, and a vital innocence embodied by a young girl grappling with a tree, armed with an unsteady ladder, against the calm orchard, and fields juxtaposed with little mountains.

I sought to capture a feeling of lightness, the precariousness of joy, "unbearable" as the writer called it. As it had been in other Champrovent landscapes. Here, the example of Poussin's immobility served me well.

I seized upon time's fleeing atmosphere as it went by, the solar rays that bolt across fields and woods, and life's fragility that Chinese masters attained economically, with almost no materials. In the same search for truth, one must try to re-create miracles based on the same nature observation in the East or West. That way the southern Sung mountains can be linked to the Vaud region, and the austere, feudal lands around Viterbo.

27

This search has also been constant in all my drawings. There is no more exacting discipline than capturing these variations in faces and poses of my daydreaming young girls. The drawing's caress seeks to rediscover a childlike grace that vanishes so quickly, leaving us with an inconsolable memory. The challenge is to track down the sweetness so that graphite on paper can re-create the fresh oval of a face, a shape close to angels' faces.

I've always had a naïve, natural complicity with young girls, like Natalie de Noailles, Michelina, Katia, Sabine, Frédérique, and more recently, Anna. Spiritual risks occur during long posing sessions. Making the spirit surge forth in a sweet and innocent mind, something not yet realized, that dates back to the beginning of time and must be preserved at all costs. There is something musical in this process, like attaining the effect of silence in a musical score, so strongly felt, for example, in Schubert. Or in Mozart's movement from fantasy to gravity, reaching what Lewis Carroll referred to in *Through the Looking Glass* as the secret "paradise of vanished splendors." There is nothing riskier or more difficult than to render a bright gaze, the barely tactile fuzz of a cheek, and

the presence of a barely perceptible emotion like a heaviness mixed with lightness on a pair of lips. I aimed at reaching the miraculously musical balance of my young models' faces. But the body and facial features were not my only focus. That which lay beneath their bodies and features, in their silence and darkness, was of equal importance. Charcoal can convey a glimpse of grace and a prayer. That's why I always reject stupid interpretations that my young girls are the product of an erotic imagination. To suggest this is to misunderstand the particular attention I pay to their slow transformation from an angelic state to that of a young girl, to finding and capturing the moment of passage.

Right: In 1953, when Balthus worked as a stage designer. *Lipnitzki-Viollet*

Below: In May 1967, at the opening night of a Rodin show at the Villa Médicis when Balthus was director. *Keystone*

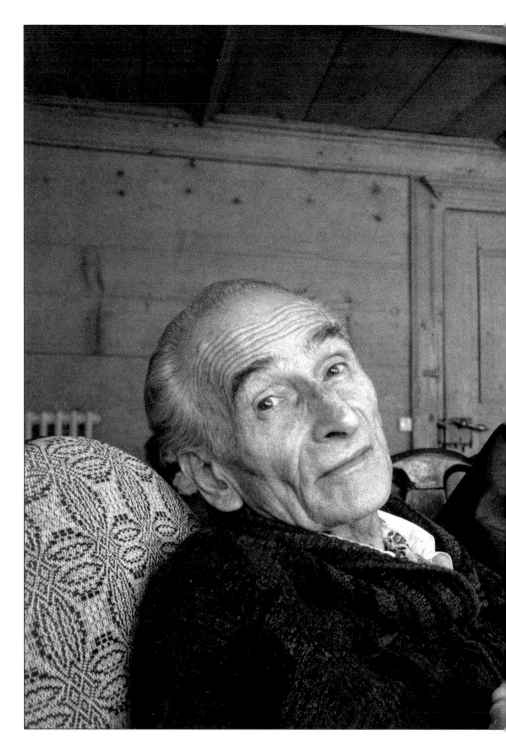

At Rossinière, the eternally youthful Balthus sitting beside Countess Setsuko and their daughter, Harumi. *H. Cartier-Bresson/Magnum Photos*

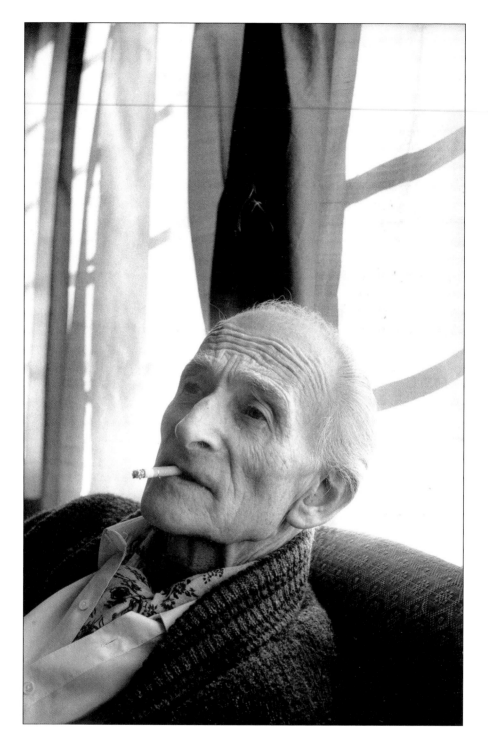

The master portraitist Henri Cartier-Bresson took his friend Balthus's photograph at Rossinière. *H. Cartier-Bresson/Magnum Photos*

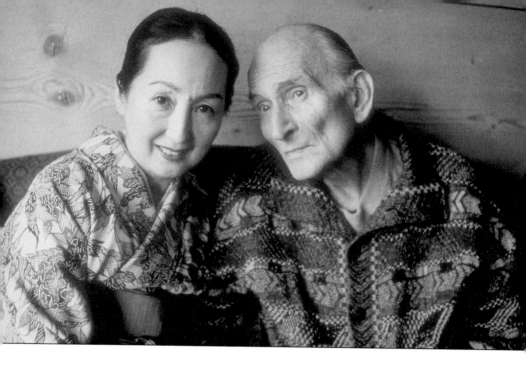

Balthus and his wife, Countess Setsuko, in their Swiss chalet. The solid ties between them provided Balthus with the total serenity he needed to paint.
P. Terrasson/Corbis Sygma

In the year 2000, the hands of Balthus and the Countess, both petting one of their cats. A calm and very gentle moment at Rossinière. *A. Vircondelet*

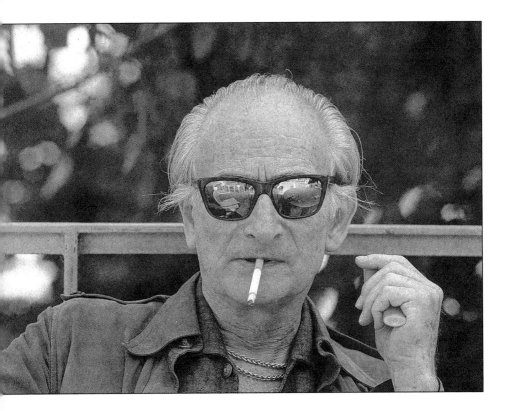

The artist Balthus. *E. Fornaciari/Gamma*

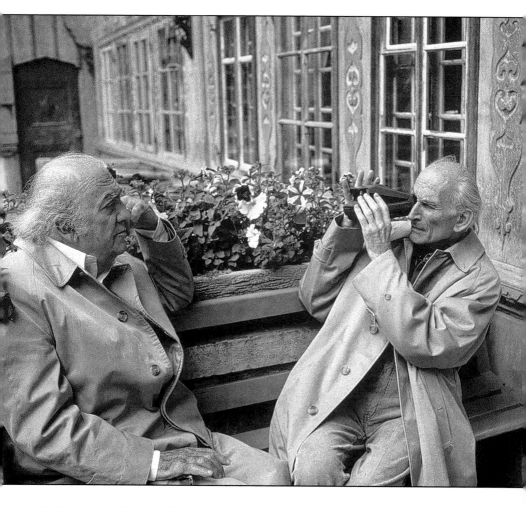

Balthus and Federico Fellini outside the Rossinière chalet. They became great friends when Balthus directed the Villa Médicis in Rome. *E. Scalfari/AGF/Gamma*

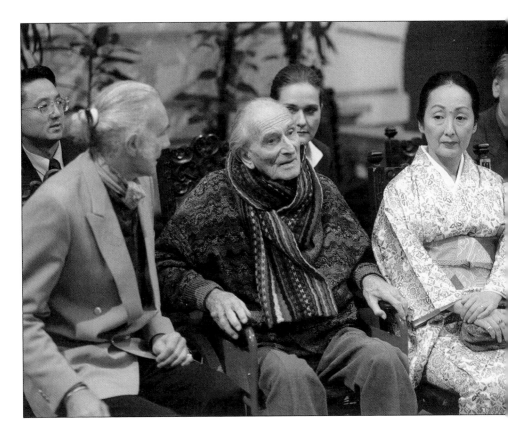

In 1997, Balthus flanked by his son Stanislas and the Countess Setsuko during a trip to his native Poland. *E. Grochowiak/Sygma*

28

Drawing is a great school of truth and exactingness. It brings us closer to nature's most secret geometry, which painting doesn't always allow us to do, since more imagination, stage direction, and spectacle go into it. By contrast, drawing necessitates abstraction in some way, since it is about going behind facial and bodily appearance and reaching their light.

It's a more austere and, perhaps, more mystical project. It entails reaching the flame of an incandescent blaze. With just a few lines the fire, despite its transience, may be stolen, captured, and grasped in its glimpsed-at splendor. I was able to do this in my portrait of poor Artaud doodled on a café table. By this I mean that the painter must have a spiritual approach, because fire is spirit and he himself is life. The painter's gaze contains spirituality, and his ability to attain it captures his model's essential nature, and deepest, most unsettling structure. Then a crossing occurs, a clairvoyance that Arthur Rimbaud wrote about.

Today, when my vision prevents me from drawing, I still have the blessing of painting. I see colors. This is a mysterious fact that Setsuko finds difficult to understand, although she witnesses it

daily. I know when she gives me the wrong color, as a kind of transfiguration takes place, an alchemical process, and I know when a little bit more Rosso Pezzari or Egyptian blue is needed; I cannot see anymore, yet I see color combinations on a canvas.

A miracle.

29

Painting that eschews facility demands confidence in one's work, and a certainty acquired by visiting, copying, and loving the masters. Once upon a time, the dictatorship by Picasso admirers was such that any painter not influenced by him was considered a Fascist reactionary hack. That's why I often quarreled with people at that time. I took refuge in solitude that allowed me to achieve paintings. Picasso respected my need for independence and my refusal to pledge allegiance to what he had indirectly contributed to establish. My work wasn't really recognized until after much time, controlled anger, and poverty. The time I spent living at the cour de Rohan was both the loveliest and most impoverished of my life. But there was something great in that solitude and poverty. It allowed me to advance.

Of all the painters of that time, I still have a powerful memory of Derain.[7] His stature, the power he radiated, and the creative force of which he was capable impressed me. In 1936, I painted him full-length, draped in his large striped dressing gown. I believe

7. André Derain (1880–1954), French painter.

the painting is in New York's Museum of Modern Art today. His robe touches the floor, so one doesn't see his feet, and he seems massive, taking on an ogreish appearance.

During these years, I painted many portraits, often commissions, alimentary work which fascinated me nonetheless because they permitted me to continue my own research, advancing my interests. Thus I made portraits of the Vicomtesse de Noailles, the Mouron-Cassandre family, Miró and his daughter Dolorès, and Rosabianca Skira. To paint is not to represent, but to penetrate, to go to the heart of the secret, to work in a way to reflect the interior image. The painter is also a mirror; he reflects the mind, the line of interior light.

He agrees to condense his gaze and hand into this dark, unbreakable core, hidden within, to project himself toward it, and to draw from it the true identity of the person being portrayed. It's a difficult thing, an alchemy that demands much concentration and resistance to the outside world.

I think Picasso understood this, although at the time, our paintings took completely different directions. Unlike the Surrealists, I didn't want to express diverse injunctions, the effects of chaos, and unconscious flaws. Instead, I wanted to reveal and expose them by way of a structure, arrangement, and construction. I had to re-create this mysterious condensation of being. Of course, this had to be done far from any care for worldliness. A portrait is a captured fragment of the soul, a gap in the unknown.

30

No doubt for these reasons, I don't like Chagall. This was a major topic of discussion with Malraux. He valued his painting, and didn't understand my reservations. I always found Chagall's painting anecdotal, with something false about it. I judged his naïveté to be artificial. He had a lightness which prevented his entry into what Rilke called the "crack," or wonderland. Anecdotes appear too easily, and niceness rules out the mysterious, blunt, fierce, and unexpected side of people and things.

I was also disappointed by Rouault's ultimately boring "here's the way it's done" approach. Inventing nothing, Rouault doesn't know how to transpose the world to give it an interior contrast, and attain its interior space.

In my portraits I try to glimpse "other splendors," as Rilke stated when I was just fifteen years old, to capture the tiny space where day is replaced by night and vice versa.

It suffices to observe, study, and be enveloped in it. To really love. Then something obscure, distant, and profound is acquired. I did this in the portrait of Lady Abdi in 1935 in which she is posed expectantly. And in the portrait of the Vicountess de Noailles,

painted in 1936. She is someone to whom anything might happen; in her relaxed pose, she is ready to pierce through the mystery.

I've applied to my painting this natural aptitude for surprise and wonder that rips away large window curtains. Painting must be prepared to accept magic.

31

Rilke maintained that I must accept this magic a priori, this entry into the marvelous world of painting, in profound areas where light is found. I was born on February 29, so my birthday can only be celebrated every four years. I'm pleased by this calendar oddity, created by the movement of the stars. I've always noted it with a grain of irony, like a mark of strangeness. Rilke wrote to me when I was fifteen years old:

> *This discreet birthday that most often dwells in a form of the beyond, certainly gives you rights over many unknown things here below. My dear B., I wish that you may be able to introduce some people on our earth to growing, despite the difficulties of our unsure seasons.*

I've always tried to follow his request, and be faithful to his wishes. My painting has merely to "introduce" some moments, unusual encounters, when my visions of the beyond pierce through. Unlike the Surrealists, I never sought them in the odds and ends of the stimulated unconscious, or automatic writing.

Rilke's aspiration was poetic and spiritual, and he summoned me to the place of the "crack," to the slit that I had to pass through, starting with my student years, in order to reach true reality. He added that I mustn't be swallowed up in the "crack," but my duty was to bring "splendors" back from it.

There were no further explanations or exegeses, and I often smile at interpretations made of my paintings, and projections that certain well-meaning art critics conceive, which are indeed far from what I put into my paintings. I have no idea what they mean to say, but they exist. Perhaps there really is nothing to say, and all that matters is observing. I sometimes spend hours this way in the studio in front of my canvases. I look at them and enter into their mystery. Rilke guided me, making me enter into his night.

In its way, this experience is comparable to that of the mystics. They climb to the House of God through the deepest dark of night, as the price to pay for the light. That's why I admire Saint John of the Cross's poems; their night crossing rewarded by ecstasy, the gift given to him by God.

"This lifts me up and carries me away," is what my mother claimed I said after reading a small bound set of Dante's *Divine Comedy* that Rilke gave me for Christmas. I was fifteen. Art has the spiritual power of elevation and ravishment in the true sense of the term. One can only create with this feeling of altitude, abandonment, and spirituality. Having this faith, I was able to create paintings for the Beatenberg chapel. With Dante's ardor and certainty.

32

After some reflection, I think that my path was determined in childhood. My parents contributed to that path through their artistic connections, the painters they invited to their home. These painters put my hand on the easel, so to speak. Also the introduction to my father's favorites, above all Piero della Francesca, and Cézanne—his fruits that are almost nothing, and yet everything. All these were the incredible grace of a childhood, never seen before and never captured again. Bonnard and Cézanne clearly showed me what needed to be painted. Rilke wrote of a world both visible and invisible, a place where reality and dreams are juxtaposed and transport us. That's why I loathed Gustave Moreau, whose painting is so short-winded, where everything is so turgid and decorative that the secrecy and truth of painting are by definition excluded. Also the Surrealists, from whom I feel so estranged, even though some of them tried to associate me with their movement. They didn't understand that painting has no place in their hodgepodge of images and secondhand goods, in which everything is so studied and false that there is no place for the upheaval that inspires painting by suddenly attaining real life, which is under-

ground, secret, and vivid. For these reasons, there were real clashes between the Surrealists and myself. The surreal is not that far removed from the real. It deals with a fragile passage. For example, the flight of a diaphanous, frail moth in my painting, pursued by a young girl who tries to prevent the insect from being burned in a gas lamp. Painting must transcribe this passage, this toppling. Nothing is more difficult. It requires months and sometimes years of work, meditation, scruples, and setbacks before the correct result is achieved. That's why for me, Surrealists set up games as artwork. Automatic writing and games of consequence are not art but exercises, amusements that have nothing to do with the practice of painting that, beyond the skill it involves, is a metaphysical and spiritual approach, a true pilgrim's progress and deep discovery, grave in the full meaning of the word. Painting cannot be toyed with in this manner. Fortunately, I believe that certain painters who have been linked to Surrealist painting do not really belong to it. Though Dalí, whose work was at first so careful and sumptuous, never managed to detach himself from it, Miró was an example of a painter who was able to distance himself. Miró's playful nobility, his lightness, humor, and derision about the human condition, pleases me. He invented a lot, and in his figures and forms an innocence, youth, and human truth come through. Picasso was wrong to joke that everything in Miró could be summed up as "hoops." His early, mathematically abstract pictures are highly worked. In them, I recognize the labor required for universal painting.

When Paris's Centre Georges-Pompidou opened, its popular-

ity worried me. I've always been wary of institutions that enjoyed instant success and popular approval, institutions that use artworks as pretexts and political justification for demagogy. I was still at the Villa Médicis at the time, and said that the crowds of people who engulfed the museum couldn't see the paintings there; a true encounter would not be possible. In response, I was told that these visits could be initiatory and educational. I didn't believe that for a moment. As a joke, I stated that only a few hundred visitors per month should be allowed in the Centre, to be shown only thirty predetermined works of art.

Modern society can never imagine painting's unsuspected requirements. If one wants to enter into painting and arrive at painting's heart, these demands and deliberation must be accepted, but contemporary painters cannot resolve to do so. At the end of his life, Picasso painted dozens of canvases per week, surely fulfilling an anxiety, but that's another problem. If we could return to Giotto's deliberation, Masaccio's exactitude, and Poussin's precision! Or we might at least admire the effects in their works, so that we could appreciate the demands they exacted. I myself have always felt a ferocious attachment to them that has never diminished. How can one paint except with this deliberate and mystical progress?

For these reasons of accuracy and truth, I loved Alberto Giacometti, who was like a brother to me in painting. We shared similar ideas and intentions about art. His work on faces was exemplary. It appeared right after the Surrealist period. André Breton didn't understand Giacometti's care for precision, the way he

wanted to capture the secret of being with the lightness of a pencil, solely through the grace of lines. A few lines were enough to make a face touching, to create a stunning arrangement in which an entire life seemed assembled. I also loved drawing for these reasons. Today, it's difficult for me to revive this technique and subtle grasp of the human soul because my eyes have betrayed me, but I've tried through my drawing to come closer to man and his inner emotions. It was a test of patience, but when the drawing was done, I perceived a personal advancement, of being more of a man, and closer to other men. Drawing certainly gave me this feeling of brotherhood more than painting did. The feeling that I was approaching a certain truth. In this way, painting is a real quest, a form of pilgrimage.

My intimate relationship with Christianity parallels my conception of painting, although I don't define myself as a Catholic painter. I've always considered painting as a quest for wonderment, a bit like the Magis' night march to Bethlehem. The guiding star must be followed, in order to reach the apparition. It's a difficult thing to understand today, especially in the domain of painting, which contemporary painters have totally betrayed. Conceptual research, abstraction, revolutionary aesthetics and ideologies have managed to devalue the face and landscape, presenting them as reactionary remnants, heretofore useless. Suddenly, the entire millennium-long relationship between painters and the divine has disappeared. Supposedly, modern art has separated painting from its origins, from cave paintings of Magdalenian art that were in direct contact with the spiritual and sacred. All that was swept

away, and today we see the disastrous effects, the deserted battle-field where only corpses are left, with obscene remnants of speculation.

From there, we can only return to the wisdom of Italian fresco painters, their slow patience, love for their profession, and their certainty of achieving beauty.

33

The humility of the early Italian painters constantly compels me to imitate them. Personality cults by contemporary painters infuriate me. One must seek the opposite, fade away more every day, find exactingness only in the act of painting, and always forget oneself. Instead, one sees nothing but self-exhibitionism, personal confessions, intimate avowals, auto-voyeurism, and egoistic declarations. I often say that one mustn't try to explain or express oneself, but rather the world and its darkness and mystery. Along the way, one might find some clues to one's own personality, but that isn't the point. Sometimes I feel annoyed and resentful over not having had the easy career, open doors, and royal welcome that some painters have found easily, perhaps too quickly. But I've always persisted on the path of solitude and exactingness. Painting cannot be done amid the world's hubbub, by adopting its rhythm and complaisance. It is better to seek solitude and silence, to be surrounded by past masters, to reinvent the world, not be cradled by false sirens, cash, galleries, fashionable games, etc.

Real modernity is in the reinvention of the past, in refound originality based on experience and discoveries. I felt most liberated

when, as a young man, I copied paintings by Poussin and Piero della Francesca at the Louvre and in Arezzo. What modernity I found in them! The painter is nothing in the adventure of painting; he's merely a hand, a tool, or link that transmits and leads, not always knowing where he himself is going, but acting as a transmitter of dreams, of the unknown, unreadable, and secret.

We know when we've touched on something essential, when there's a point of juncture or welding between oneself and what one is trying to reach. It's a sacred story, like the fingers of God and Adam that join in Michelangelo's Sistine Chapel painting.

Yes, painting is at this border or boundary. To get there, it must be understood that one needs to divest oneself, leaving aside one's puny ego.

Paint amid the trills of *Così fan tutte*, because genius roams there, paint while looking again and always at Courbet, Cézanne, Delacroix, and my beloved Italians. The painter exists only in this personal availability and humility. Let others try to interpret, understand, and analyze by any light they choose. The painter knows nothing of this. He paints, that's all, and does not seek to translate.

Silence is what he must try to attain by all means. That's why I find any verbal approach to painting derisory and superfluous. What word or words could capture the silent, secret, and dark spaces in which we try to find meaning, and bring back some traces of it?

34

My happy childhood, protected by affectionate and attentive parents, and associated with exquisite poets and artists, was formative to my life as a painter. Basically, everything came from the innocent and gentle gaze that one must have in order to be devoted to painting. I was lucky to have been raised in an extremely cultivated and refined environment. My father, Erich Klossowski, was an enlightened amateur, an informed art historian, painter, and critic. Among his friends were famous art dealers and discoverers like Wilhelm Uhde, who made the Douanier Rousseau and Picasso fashionable. I recall explicitly a trip I made with my parents to Provence at age five. I never forgot a word that circulated in the conversation: Cézanne, Cézanne . . . the word was pronounced like a talisman, password, or magic spell. Rightly so, for when I was old enough to discover his painting, I realized that its novelty was in the ability to grasp the secret of things, from apples to landscapes.

Later, the artistic atmosphere of my home inspired me to paint. Seeing my mother make charming sketches and sensitive watercolors enhanced my natural inclinations. The presence of

Rilke, who lived with my mother after she separated from my father in 1917, comforted her. In 1919, when we met, Rilke became very interested in me. I accepted his advice and watchfulness, although I missed my father a lot. Sometimes I resented my mother and took umbrage at Rilke's presence. After war was declared, our life became rather difficult. Exiled from Paris, we moved precariously to Berlin, where all our possessions were confiscated and authorities kept close surveillance on our father, who was thought to be a subversive Pole. Then came my parents' separation, life in Bern and Geneva with my mother and brother, Pierre, and the return to Berlin in 1921. During this life of wandering in exile, on the verge of poverty, my greatest fortune was in artistic apprenticeship acquired by proximity to masters I'd discovered: Dante and Wang Wei, as well as moderns whom I'd actually met. I felt that I truly belonged to their tradition, which I'd learned to connect with by following in their footsteps. Deliberately, I started to draw and paint, and to write a Chinese novel that Rilke often asked about. Rilke's natural naïveté, childlike gaze, pellucid poetry, and refined thought helped me in my vocation. He was convinced that painting was my path, as a line of truth.

The forty images of Mitsou, my lost cat, with an introduction by Rilke, were my first entry into painting.

35

One of the definite marvels of my youth was Beatenberg, Switzerland, where we lived each summer. It was located above Thun. My health was rather fragile and Switzerland had a reputation for perking up invalids and sickly residents. For me, Beatenberg evokes vast, superb landscapes, mountains for which I always had a real predilection, and a certain kind of inhabited solitude. I felt that the spirit breathed better here, where essential natural forces and powerful energies ran freely. Harmful city air cannot be found there, as it is eliminated automatically. This majestic environment inspired my first painterly emotions before I really became a painter. Amid the bright light and the notion that everything may endure, I felt nothing could be subject to our poor world's hazards and demolitions.

Rilke joined us and watched over my sensory education, giving me a book of Chinese paintings from the great Sung period. From this book, I got the idea that everything is similar, the Orient and Occident, the Alps and the refined, steep mountains of ancient China. Everything met and blended in light and universal prospects, ageless and without historical landmarks. All came from

the world's ancient resources, a history shared by all men. Thus landscape is linked to a spiritual dimension, a planetary continuity; even as a youth, I intuitively perceived its full significance. Life at Beatenberg was very simple, a true pastoral life with real farmers in real wooden houses. This daily life far removed from fashionable society conventions allowed me to develop a real passion for folk art. When we moved into Grand Chalet, we were delighted to preserve certain furnishings, like a ceramic stove that may have warmed Goethe or Hugo, and creaking wooden partitions that bring us to nature and traditional country dwellings. Although they were not built with cement, they have survived modernity's threats.

Perhaps this is where my personality—referred to as secretive, fierce, and untamed—was formed. I cultivated the taste for a certain secrecy, not in order to make myself important or attract galleries or collectors, but because the path of silence and withdrawal is the only one that allows access to art's secrets. Therefore I feel closer to the Vaud region's farmers than to painting's professionals. I love rustic furnishings, which have grace and truth. Folk imagery and minor arts always fascinated me; surrounded by them, one feels the artist-artisan's sincerity. My mistrust is always aroused by insincerity, affectedness, and posturing. Painting can never result from these inclinations.

36

The taste for withdrawal is not a desire for flight, a despising of the world and humanity, or an exasperated solitude. The need for asceticism is linked to knowledge of others and the elucidation of mysteries. Being in the world means to risk diluting the mysteries, without ever understanding them. Basically, my homes were always places for withdrawal. In feudal castles and monastic enclosures it was about seeing the world and hiding oneself from it, being present and absent, always open to visions of what is secret.

The cour de Rohan, in the Commerce-Saint-André alley in Paris's Odéon neighborhood, also conformed to my lifelong need for hidden geometry. My studio/bedroom was a quiet refuge from easy temptations and self-limitations, a way of reaching what I had foreseen. For these reasons, in 1954, I needed still more silence and solitude.

In 1962–1963, I rented a fortified farm in the Morvan region, at Chassy, with my niece Frédérique, who lived with me before Setsuko came into my life. In the golden light of the Yonne River's surroundings, I devoted myself to drawing and landscapes, imbued with the joy that this visible seclusion brought me. Perhaps there I discovered the old feudal instinct that is part of me and that I love

to cultivate; the power of old buildings at Chassy and Monte-calvello is partially why I chose them.

Light conditions at Chassy occupied me at first, or "preoccupied" me, as my friend Jean Paulhan[8] would have said. In the huge landscapes lit up by sunrise and sunset, the brightness of origins and glory that they impose, I sensed something that became suspended and worrisome through the peace and calm. In serenity worthy of great Chinese landscapes, I perceived the famous moment of the "crack" of which Rilke spoke.

Thus, in my landscape compositions, I concentrated on capturing the individual, bewitching light. The large landscapes I painted were all "read" under the seal of this apparent timelessness, developed from inside by violent, vibrant energies, and by the light's shimmering, the bronze finish also found in Velázquez and Rembrandt. I studied in depth the mystery of morning and twilight mists, the matte velvet of the fields, and the triangular light effect surrounded by hedges. Also at this time, I studied young girls as seen from behind, looking out the window like a favor bestowed amid nature's sovereign fixity. And multiple attempts at faces in which the pencil tries to attain a troubling mystery. Frédérique consented to it, lending her adolescent face to the insatiable quest.

But nothing is attained, as the poet says. Deeper nights still had to pierce my landscapes and faces. Other enigmas had to be intercepted, and other surreal realities, drawn from dreams and "wonderland," had to be transcribed.

8. Jean Paulhan (1884–1968), French writer and editor; the wordplay of "occupied" and "preoccupied" conveys the slightly precious tone of his writings.

37

Perhaps I was able to venture so easily between the Orient and Occident because early on, I was accustomed to a world of analogies, familiar with border paths, and curious about trails. In my eyes, regions like Le Bugey, Morvan, En-Haut, and Montecalvello are identical. They recall passageways linked by mysterious correspondences. Why did the Grand Chalet, which we lived in, seem like a Taoist temple? Why did we immediately feel at home there? Since childhood, I know that dreams slide by in other worlds and secret paths, revealing or predicting unknown space that could not be imagined from the countryside's calm, the ever-docile days, and the light's peaceful coolness.

In 1943, when I had my first Paris exhibit at the Galerie Pierre, some visitors strode through, saying, "But it's figurative!" In fact, I never made what is commonly called figurative art. On the contrary, the key was to paint the mystery of climates and seasons, glimpsing the gold and transparency that weighs them down rather than describing them even for a moment. The same is true of characters and "scenes" that I painted, *The Moth*, *The Nap*, or *The Coffee Cup*, for example. I never thought of Freudian interpre-

tations (I am extremely wary of psychoanalysis) for the unusual, strange scenes I painted; I wanted to paint a dreaming young girl and what passes through her, not the dream itself.

The passing, therefore, not the dream.

The Surrealists tried this approach. As I see it, they explained, translated, and interpreted it. But in doing so, they overloaded what was as light as an insect, a moth irresistibly flying toward a gas lamp's golden halo.

As a close observer, I discovered, by remaining discreet and without overloading the canvas with my presence, the dreams I gave my dreaming young girls, my abandoned girls, my half-sleeping angels. Displaced in relation to the subject, askew in a sense, I can grasp another point of view, another climate into which my young angels thrust themselves as they fade away.

But the painter's role is not to violently express this passing; technique alone can convey a displaced effect through poetic distancing. The masters of Siena helped me greatly with this. I recall their frescoes with matte, almost rough, surfaces, and subdued, muted colors, like the green in Pompeii's frescoes, heavy pinks and ochers, which I feel are time's colors.

There's nothing better than the Italian fresco painter's gesso, which I discovered during my youthful travels, to which I added casei to bind the colors. To recall the Old Masters' artisanal work with ritual preparations that produced an effect of suspension, or surprising expectation, of time finally mastered.

Time mastered; isn't that perhaps the best definition for art?

38

During my army service, I brought along some books by Henri Michaux[9] and read them often. Which says a lot about my concerns and poetic direction. Michaux's poems and texts are trips through a mirror; *La Nuit remue* and *Les Aventures de M. Plume* aspire to crossings and imaginary travels. At Chassy, I seemed to fulfill my reading of Michaux, not only in the temptation and eternity of landscapes, but in the feverish will to cross space and time, amid the rustle of angels' wings that allow us to attain the reality of dreams. The secret motion of people and things.

In fact, I never sought to keep company with dreams. They were imposed upon me. Perhaps it started long ago, when my mother wrote and spoke widely about my inclination for "apartness," being "to one side" or on the edge, and the seesawing that allows one to suddenly cross to another place.

I tried to do in painting, and later in ink drawings, what Michaux did in texts. I tried to transcribe a dream's area by material means like colors, with light on thin and fragile colors that

9. Henri Michaux (1899–1984) published a book entitled *Curtain of Dreams*.

achieves transparency. To make the canvas perceptible by the characters' floating state, so lithe as to seem unsubstantial. To make the canvas convey the secret internal vibrations to which a dreaming girl is subject. As I always say, the painter's essential skill and work are indispensable to expressing these conditions. Simultaneously, we must feel time passing through the gesso's matteness, and the circulation of life and juice going through it. Time and time's vibration. As Michaux would say, an "interior space" on the other side of the curtain.

There is nothing to interpret in what the canvas says. Nothing to be said about it, after all. It can get along by itself perfectly well. No codex or dictionary required. Dreams continue stories that are lived in the daytime. In the studio. They reach the canvas's reality and command attention by their disturbing strangeness, without the help of any analysis whatsoever.

39

Behind nature's docile stillness and people's behavior, I've always perceived a secret, dark complexity that attracts all artists and makes them advance to the depths of forests and the abyss. This mysterious architecture gives art its vertigo. As a young man in 1933, I made sixteen pen-and-ink illustrations of Emily Brontë's *Wuthering Heights*, which I admire greatly. I was inspired by the romantic passion that breathes through it, and its harsh characters. I'm not sure that I gave my features to the protagonist Heathcliff, but looking at the drawings today, I find traces of my former rebelliousness, now calmed, and the fierce violence that was inside me. In any case, one always paints oneself and one's own personal, secret story; otherwise there is nothing but technique and facility. The glorious gentleness that I discerned and tried to interpret in the landscapes of Larchant and Champrovent mustn't overshadow the scenery's other side, namely the agitation that must well up behind it. Even Poussin's enchanting, perfectly ordered paintings include such uneasiness.

Yes, my romantic youth must have included a fascination for Heathcliff. The notion that the artist can never be totally allied

with the world, but lives in a salutary exile. Every attempt at expressing the world through painting brings him to the greatest challenge, of dissolving into the created work, and being inside the work: Courbet's trembling, silken women's flesh and vibrant foliage undergrowth, Bonnard's juicy, ripe fruits, and Chardin's children. But behind these scenes of children and nature, how many internal tremblings, suspicions, and threats that alter a life, forcibly transcribed and conveyed by the painter!

That's why his work is slow and cautious. In the studio, I often smoke a few cigarettes in front of a canvas or even move my hand across, caressing it. This is also part of painting, and may take an entire day. The contact or union with a canvas-in-progress establishes a familiarity that is removed from today's omnipresent haste, which speeds time's tragic winepress.

40

Life at Rossinière granted me the grace of time regained, dominated and subdued. Despite old age's infirmities, I owe this serenity to the Countess Setsuko, who adorns the passing days with gentle, peaceful harmony. I particularly like winter evenings after dinner when we settle in the library, where we have installed a wide-screen television. Among the films we watch on it, suddenly filling the large dwelling with stereophonic sound, I particularly appreciate action and adventure films, American westerns, or else, operas. I have film-actor friends; Richard Gere, whose photos of Tibetan monasteries I admire, Tony Curtis, Sharon Stone, and my great friend Philippe Noiret all visit me at Grand Chalet. Film, with its lightning flashes of imagery and surging technique, is the opposite of my painting, which tries to capture the hidden tension of things, people's internal violence. It instructs time to stop its infernal race. Yet, painting and film are connected in their striving for deeper elucidation of the world.

An extraordinary example of this was Fellini, with whom I had many collegial moments in Rome and Rossinière. We got along well because we shared the same quest and desire: moving images

for him; and for myself, painting that sought fixity in order to disturb and unsettle. My painting wound up being as mobile as his art, with its overabundant flow of imagery that contains a highly secret personality. Both of us wanted to cross over, step across, and—always returning to the same word—arrive.

41

Fellini and I developed this closeness of spirit during my stay at Rome's Villa Médicis. I recall our walks in the Academy gardens amid timeless objects, while around us, Rome moved and bustled, introducing changes that modern life would develop. We spoke of a thousand things while savoring the Villa Médicis' conserved calm as a silent time capsule of history and tradition, without which everything seems useless. The first time I took Fellini to my studio at the back of the gardens, three canvases were in progress. I always paint several canvases at a time, adding a daily line here and a new color there, as I meditate and dream before them. That's how the painting advances, in a constant conversation or dialogue held with it. Intimate, murmured.

In one canvas, a young girl is reading, and in the other two, Japanese women lean over their mirrors. Later I called them *Katia Reading*, *Japanese Woman with Black Mirror*, and *Japanese Woman with Red Table*. Fellini said nothing, but later he told me that he felt they were "relics" that I had "exhumed, brought to light." I liked what Fellini said. I was glad to hear his words describe what I aimed for by assiduously working with light; a rediscovery of the

silky feel of chalk I so admired during youthful study trips to Italy. Yes, my explorations sought to end up with something rediscovered.

With this attitude, I embarked on the Villa Médicis' restoration. Everything had faded. It was not abandoned but worn out, colored by time that would have erased it all. I took up the challenge, with Roman artisans who had a spontaneous grasp of the old art of gesso. We started to restore the Academy's exhibit spaces in order to provide a proper setting for the works shown; the only decorative element was the renowned color of time, shadowy and indeterminate, upon which the works of Braque and Corot could suddenly vibrate with their individual violence, a trembling blinded by their secrets which also emerged from time's abyss. I knew that the lighting from mirror-reflecting candles, "deep mirrors" as Baudelaire said, would animate the walls. The project that I freely chose contained creative value and personal spiritual progress, in the great questioning of the world. In its advent.

42

The Villa Médicis' residents, artisans, and I lived through joyful, exuberant days that compensated for the jobs we took on. I gladly accepted André Malraux's assignment. Everything remained to be done. The Villa was asleep, not in ruins, but its former royal glow was obscured by a certain weary decline. I worked ardently to restore it, abetted by the Countess Setsuko, who helped me in the effort, while greeting and receiving guests. The archives were of invaluable help, and we found maps of the old gardens with concealed buildings that we brought to light, intact frescoes of all sorts of bird species that sported about in aviaries, emerging from their overlong night. I had the walls painted, giving them a vibrato to contrast with the cartouches, emblems, blazons, and friezes. The obelisk from Santa Maria Maggiore, which had been in the exact center of the gardens in all the old engravings, was no longer there. We had an identical copy sculpted from natural resins and powders. I recall when it was raised in the middle of the *bosco*. What joy for the residents and what personal happiness I felt to restore life to a past for which we were responsible, as reckless and forgetful heirs!

The story of my childhood is akin to this desire, "reactionary" in the true meaning of the word, to preserve traditions in order to be able to innovate and invent in turn. I was raised in an environment devoted to admiring and respecting the past in order to better advance oneself. The world was never remade starting from nothing, but from reading, listening, and playing differently, with the inexhaustible legacy of those who preceded us.

43

I learned much from Piero della Francesca: his way of filling space in his paintings, of dividing it by placing diagonals that give order to the whole thing. His work constantly advances order, in a way that I see all his paintings as advances toward perfection. By imitating this master, I myself have constantly tried—with the powers and stubbornness I'm said to have—to vary the points of view in some of my paintings, the way Bach did, for example, endlessly returning to a theme, lightening, stretching, and purifying it. Cézanne also returned to Mont Sainte-Victoire until it became a power line, a tension cable, in the landscape. The same is true of his apples, which from realistic objects become circles, planets, essences, lines that express total power in the form of apples and their juice.

My paintings' repetitions must not be seen as a neurotic or pathological obsession. Nothing could be more demeaning than to think of painting as merely an outlet for anguish and dream imagery, or more false than to believe in the projection of one's fantasies. Yet most Surrealists claim this with ironclad conviction.

My series of *Three Sisters* or my *Cats at the Mirror* involve more complex requirements that still remain simple. Returning to a

theme answers my internal mathematics, so that my dissatisfaction serves as a stage, passageway, or springboard to better attain a work's secret, what the canvas wanted to express invisibly, unbeknownst be me, and for which I was a mere instrument. That's why painting requires self-abandonment and taking ever more pains, along with the absolute refusal to constantly proclaim one's ego as one might brandish a flag.

44

Often the requirements that I describe, and the interior power a painter must command, are misunderstood. They are called reactionary and old guard by people unaware that work, or I should say labor, and perseverance are the only guarantees of a work's authenticity. I've always professed this determination, even at times of poverty and when I lived on the cour de Rohan. When the Beaubourg Center was built and people rejoiced to see thousands of visitors marching inside every day, I must have been one of the few not entirely convinced that we should rejoice. This reserve was taken as haughty disdain or a sign of pride. Of course it was nothing of the kind.

I had a rather harsh conversation on the subject with Marguerite Duras when she was invited to spend a week at the Villa Médicis. She asserted that art must be revolutionary, crowd pleasing, open to everyone. I replied that the exact opposite was true, and even provoked her by saying that I envisaged the Center as open for about thirty visitors per month, who might thereby have the time to interact with the works. The Center's crowds and din were loathsome to me, the complete opposite of what artworks

demand: silence and interior music. Marguerite Duras didn't appreciate my comments and flew into such a rage that she refused to sleep at the Villa, passing along her impressive room, the Cardinal's, to her son.

This anecdote explains part of what I expressed above; today we've forgotten the millennium-old virtues of silence and work, the secret and profound dialogue with the invisible, which I also call the divine, and its visible reconstruction on a canvas that comes from a distant, ancient place. Instead of this, I see only self-exhibitionism, brouhaha, and spontaneously impulsive inspiration that presumes everyone can paint. The democratization of art, therefore, means its banalization by an artist who has the ignorant arrogance to consider himself a creator, that is to say God Himself, if I understand correctly.

45

That's why the artist must not become a storyteller. The anecdote should not exist in painting. A picture or subject imposes itself, and it alone knows how profound and vertiginous it is. Nothing happens in a picture, it simply is; it exists by essence or does not exist at all. Baudelaire said a poem is there before it is there. Otherwise, it would be akin to something narrative, something inflected, willed into being by the artist. A picture or poem escapes these contingencies, with terrifying freedom and fiercely self-sufficient violence. In this sense, the artist is a mere link in a chain that began long ago. At Lascaux, for example, and even before Lascaux. There is no hierarchy, and Chardin is not better than Lascaux. All these creative connections belong to the same earthly song, from the ancient source of the world that I know nothing about, but which sends me a few messages by flashes of sun—or starlight. The artist constantly seeks to rediscover the illuminating fire, the hearth where sparks are made. Mozart knew this, drawing his fluid musical movements from this mysterious source, with the grace to bring them to light, our light. That's why I listen to Mozart so religiously, with a quasi-sacred delectation

and jubilation. I also listen to Mozart the way one prays because his song captures the world's secret vibrations. In painting, the same grace, the same quest for harmony, must dwell in the artist. My subjects, landscapes and children, know this miraculous condition perfectly well. The powdery contours of a child's cheek or the clayey roughness of a quince fallen from a tree before the first frost. Once again, Baudelaire's analogies come to mind: "There are perfumes cool as children's flesh / sweet as oboes, green as prairies . . ."[10]

10. From the poem "Correspondences" by Charles Baudelaire (1821–1867).

46

In 1965, I sent a short telegram to the art critic John Russell, who requested some anecdotal details about my life to fill out his introductory text for my Tate Gallery retrospective exhibit: "Start this way: Balthus is a painter about whom nothing is known. Now we may look at his paintings."

To my mind, this was no mere quip or coquetry. Of course, I have always thought that a painter's only viable, meaningful, and trustworthy expression is in his paintings, which he spends so much time doing, with such complicity, and which say more than any speech. I resolved to write these short memoirs in the form of brief meditations, in the style of Montaigne, but these few essays aren't the product of any testamentary concern; rather, at my life's sunset, I feel the need to assess certain moments of my life, which have defined and distinguished it. My life was a long labor, although I'm not complaining. On the contrary, my closeness to painting and the continuous dialogue I've maintained with it have replaced all worldly glories, which, I'm told, some people now accord me. To tell the truth, I'm indifferent to this recognition. It's enough to know the unspeakable happiness any painter must feel

in front of his painting. The unspeakable happiness of rediscover-
ing my studio's warm atmosphere, of crossing the small road that
separates it from the chalet, of getting back to work. It is monastic
work in some way, with a regularity comparable to the dogged suc-
cession of days and nights—the first appearance of snowflakes
each winter, or the greenery suddenly covering the mountains at
springtime. Where I lived—at the cour de Rohan, Champrovent,
or Chassy—didn't make a real difference. There's nothing but a
tenacious, stubborn-minded faithfulness that's no longer a choice,
but something consubstantial with oneself, essential and destined.

47

I've been a painter who loves to read. Now that my eyes no longer allow me to enjoy a patient dialogue with books, I ask my faithful Liu or the Countess to read to me. Television and music have gradually replaced the assiduous association with texts. I often paint young girls who are reading. It's surely because I saw the act of reading as a way to enter into life's deeper secrets. Reading is the great means of access to myths. Green, Gracq, Char, Jouve, Michaux, and Artaud were frequent passageways, as well as the great holy writings of the Bible and initiates like Dante, Rilke, the Pléiade poets, the great Chinese writers, the mystics John of the Cross and Teresa of Avila, not to mention Carroll, the pure German poet Ludwig Tieck, and Indian epics. All these texts and authors were landmarks in my life, and gave me another dimension of time to which I soon felt myself summoned. My young girls who read in dreaming poses are escaping from fleeting, harmful time: *Katia*, *Frédérique*, and *The Three Sisters*. Fixing them in the act of reading or dreaming prolongs a privileged, splendid, and magic glimpsed-at time. A suddenly opened curtain sheds light from a window and is seen only by those who know how. Thus a book is

a key to open a mysterious trunk containing childhood scents; we rush to open it like the child with butterflies, or the young girl with a moth. It is a gold-sprinkled time that avoids worldly alteration, time nimbused by a magic halo, time fixed in terms of what the smiling, dreaming girls see. It is surreal time in the true sense of the term. It is not Surrealist, or what that school of painters would have done with it.

What book is Katia reading? I don't know, and it isn't even my business to know. All I am sure of is that by reading it, her attentive gaze seems to guide her toward worlds whose smooth-surfaced walls are painted with colors "that don't exist," as Hoffmann might have said in one of his tales.

That's why, although I don't read as voraciously as before, I still love at least to hold a book in my hands, its form and contents, which are signs of a call, a fervor.

48

That's why I'm attracted to texts whose unusual, strange imagination allows us to better glimpse the magical and desired "wonderland." Perhaps this attraction is due to my Scottish ancestry. It is said that one of my ancestors was friends with Lord Byron. Perhaps I inherited a taste for time's distortions, for intermediary and wildly unknown states, and otherworldly climes, from her and what the great British poet transmitted to her. Of course, Lewis Carroll's Alice allowed me to embody childhood enchantment. I saw from photographs of his model and his book that he understood that children's real nature is personally unknown—kept secrets, deep innocence, the primary angelic essence. Very early on, I heard the call of childhood, as my version of *Wuthering Heights* shows. Not only Carroll, but also William Blake, whose dazzling, luxuriant Illuminism was a creative and inventive source in his drawings and poems. Some say that artists must begin with nothing. Even Ingres told his students that too much knowledge ruins a drawing. I think that one must, instead, be like Renaissance poets who clamored to know the ancients, a tradition that became a filiation, and invented new forms based on them. This thor-

oughly understood hunger has led to great things. What would I have become without my pilgrimages, when I left my little terraced room on the piazza Santa Croce in Florence, and after small jobs (living by my wits), I went into Masaccio's chapel in the Carmine church? What would I have become without my stays at Castiglione d'Olona to admire Masolino, at Borgo San Sepolcro to try to understand the scholarly geometry of my beloved Piero's *Resurrection*, and at Siena studying Simone Martini in the afternoons? And my long pauses before Poussin, Corot, Courbet, and Cézanne, in whom I found the same asceticism and vibrant designs as in my beloved Tuscans.

49

I live in Switzerland after years spent not in wandering or exile (I mean my travels to Paris, Chassy, and Rome), but rather in stages of a fruitful pilgrimage. I have strong invisible, emotional ties with the Swiss land. When I was a young child and adolescent, Beatenberg was my parents' vacation spot, and later my mother's when she was by herself. The site of my first painterly efforts, this area made me aware of a mountain region's spiritual, altitudinous dimensions. I enjoy the naive, rustic lifestyle that the mountains of the Vaud region still retain; I feel a complicity, a sort of bonding with them. For me, Swiss mountains provide a connection to my childhood, when we toured Lake Thun, or the Niederhorn's peak with its steep corrie and ancient rocks along the mountainside, displaying faults and fixed motion in time. For me, these landscapes are revelatory, strong anchoring places that brought on the development of what I might call my secret geometry and interior mythology. In 1935, I believe, I painted a canvas evoking a grand view, *The Mountain*. I included seven people in it, remnants of those I knew and who stayed close to me, graven in my memory; there are curious tourists at the edge of a chasm, a young girl at a

dazzling gorge, some childhood friends, one of whom died of appendicitis, and another, a shepherd in a purple vest with puffed sleeves. A silhouette seen from the back—doubtless the painter himself—walks alone, leaving his figures. I recall the slow and difficult labor required for this painting. I sustained it for two years, helped by advice from Giacometti and Derain, both of whom offered judgments on the design.

Let's not sin through false modesty. Alberto greatly liked the painting's structure, and the rock's arrangement. In it, he saw some kind of Freudian interpretation that made me smile, as I myself knew I had painted *The Mountain* exactly as it still is today, with its herds that clear a narrow path between the valleys, moss-green topsoil, and slanted shadows that bring into relief the rocks' brightness, ridges and anfractuosities that reveal frightful, mysterious geological upheavals. Derain, surely motivated by friendship and the flow of sympathy he always felt for me, compared them to Giotto's rocks, which can be seen at Padua.

I have preserved this mountain intuition until today, with the understanding and learning to which it leads. In the same spot, while reading the Chinese masters, I had a revelation of certainty that the Occident and Far East are identical. The rocky, gravelly slopes of the Niederhorn are sisters of ancient China's Sung mountains.

Everything converges and combines. There is only vast earthly beauty to be grasped in its youthfully vibrant and intact luster.

50

I return to the difficulty of autobiography, which these mem-oirs require of me, and I think of Michel Leiris, my old friend, who knew that such a project is impossible. How can one arrive at what my brother Pierre Klossowski calls "the enigma," that can never be expressed? He says, "In every man there is a nonexchangeable basis." Something that isn't part of normative social rules, and can't be compared to others, making the ego stubbornly individual and unique. One cannot hope to attain the vertiginous deep one-self, what Meister Eckhart—my bedside reading—called "the deepest abyss." That's why I completely reject the erotic interpre-tations that critics and other people have usually made of my paint-ings. I've accomplished my work, paintings and drawings, in which undressed young girls abound, not by exploiting an erotic vision in which I'm a voyeur and surrender unknowingly (above all, unknowingly) to some maniacal or shameful tendencies, but by examining a reality whose profound, risky, and unpredictable unreadability might be shed, revealing a fabulous nature and mythological dimension, a dream world that admits to its own machinery.

Thérèse Dreaming and *The Mirrored Room* shouldn't be seen as erotic acts where anatomy and libido unite indecently, but rather as the need to expose and capture something that must be termed elusive and inscrutable, yet which vibrates and resonates, belonging to what Camus called "the world's beating heart."

For me, painting was a direct means, tool, and necessary path for bringing this strange banished expression to light. My brother, Pierre, also knows the odd alchemy by which a painting sometimes allows us to penetrate, and began trying to explain this in words, but finally abandoned words, somewhat like Rimbaud, in favor of drawing and painting, to which he became entirely devoted. Slowly, the need took hold, forcing him to abandon novel writing for what he calls the "mute conversation" of paintings. He says— and I believe him—"the image is a force," and adds, "I'm not trying to get to the core of theophanies." Consider a painting as a birth, an advent in the theological sense of the term, and admit its illegibility in the same way that Mary, after the Angel's Annunciation, didn't try to explain what was going to happen inside her. Her innocence about what would arise.

51

I took up the art of portraiture again, which had been aban-
doned in the name of sacrosanct abstraction, because man seemed
to me so bankrupt, or as Saint-Exupéry said, "despicable through-
out the world." I had long studied, admired, and copied the inde-
scribably unique portraits by Holbein, Cranach, and the Le Nain
brothers in the Bern museum. Commissioned portraits capturing
identities on the fly, of ingenuous subjects wearing garments
trimmed with braid. I felt that these portraits managed to express
what was most secret in their beings, beyond the historical and
local reality they represented. By their very simplicity, they
attained the "deepest abyss" that I mentioned earlier. By concen-
trating on portraiture, I also wanted to convey the symbolic,
iconic, and specular truth of those who posed for me. To somehow
convey their glory. Popular art has often managed to restore the
secret element that is in every man, because it doesn't deal with
psychological regions, but attains the real pulse of nature through
basic naïveté. It is very difficult to express, and much easier for me
to let painting speak for itself. Remember that the painter must go
into deep, archaic, and primitive history, a deliberate Orphic labor

that never dies, but is disguised or unknown. That's how I depicted André Derain, glorified as a great seer. Or, the girl who posed for *The White Skirt*, with her red socks embroidered with gold thread, satin skirt with crushed pleats, and bodice out of Renaissance painting, all emblematic of her untidy, and languidly offered, charms.

Perhaps I also recalled my father's lessons and his admiration for Daumier, who far from being a caricaturist as many believe, was a great visionary painter who extended his gaze beyond appearances, thus attaining the unfathomable. Portraits are not sociological documents, but fragments of the soul, fragile and yet powerful because they had the strength to remain alive, although hidden. The painting brings these souls back to life and strength, one might say with heraldic power. When Setsuko posed for *Japanese Woman with Black Mirror* or *with Red Table*, I sought to rediscover the hieratic figural dignity in great Chinese painting, and the still, pregnant silence this painting develops—its unattainable strangeness and opacity.

52

Everything comes from childhood, and the wanderings and successive exiles that world history imposed upon us. How not to flow along the creative current in which our parents lived? Happy days in Paris with my brother, my father, Erich, and my mother, Baladine, whose tender, oval face and sober, mysterious gaze were framed by black hair, parted in the middle. As my father was an art historian, we welcomed the Neo-Impressionist painters to our home on the rue Boissonade, and later at Saint-Germain-en-Laye. My mother attended classes Bonnard taught. He came to the house regularly. My brother, Pierre, three years older than I, took up drawing, seized by the ambiant artistic fever. It was an odd happiness, intangible and impossible to preserve after war broke out in 1914. My family decided to leave for Germany. It was a time of war and separation, of French nannies taking care of my brother and myself, and the permanent certainty of being temporary, ephemeral, and transitory. That painting should be so openly imposed upon me was no accident. It made me rediscover the world's ancient anchorings by traveling through time and regions, and gave me a flowing, sonorous reflection of ancestral fables. It

allowed me to resist life's migratory flux, by giving a glimpse of its opposite, the Vision.

I think of my mother's only portrait, in her youth. Her deep, almost brooding look, of one who hasn't abandoned the spirit of childhood, with its secrets and grace against which time sharpens its teeth. Yes, I think of my mother who helped make me hear the soft, muted music of another time that no one has managed to bury entirely. A gleaming, lively time. A time of kingdoms. Time fulfilled by painting.

53

Listening at the end of my life to Mozart's depth and gaiety, carefree lightness and deep pain, I tell myself that nothing was in vain or unimportant. My imposed crossing of a century delighted me and outlined the way. I established acquaintances and friendships with some creative minds who shaped our century. Camus, Saint-Exupéry, and his charming, talkative wife, Consuelo, who managed to make the pontifical afternoons at Pierre-Jean Jouve's home quite joyful; the most secret beings were Maurice Blanchot, Louis-René des Forêts, and Henri Michaux. The most subversive were Bataille, Pieyre de Mandiargues, and Daumal. The most spiritual were Marie-Madeleine Davy, Guitton, and John Paul II. And the twentieth century's most inventive artists ranged from Picasso to Dalí, Bonnard to Derain, Matisse to Braque. Paradoxically, all of them bring me back to the great classical masters, the priceless capital of European culture that I loved so much and studied so long. I'm a living witness, along with my friends, of wars and disasters of all kinds, deportations, ruined moral values, and easy virtue. Spirit, once compromised and effaced, must be painstakingly rediscovered through work to delight the world once again. Artists have

this duty. I believe in this sublime mission. Every painting must be summoned to the stubborn striving for harmony and beauty The most precluded secrets must be sought at the limit of things, in their otherness, whether one be sedentary or voyager. My beloved Ramuz, anchored to his Swiss region, or Segalen, whom I discovered thanks to Rilke, and whose poems from his journey to China taught me to observe what he called "diversity," enriched "abundantly by the entire universe." Painting is my way of reaching China and "the entire universe," for the mountains met there are also unfathomable wells.

54

The Chassy years, from 1954 to 1961, were among the most creative and fiercely solitary of my life. Alongside my niece Frédérique, I made numerous drawings and large canvases, mostly devoted to landscapes and still lives, so suited to this home in the Nevers region, formerly belonging to the counts of Choiseul. The massive building, withdrawn into itself, was somewhat monastic, but its closed structure welcomed visits as well as seclusion. Pierre Matisse and his wife, Giacometti, and many other friends joined us there, sharing the same desire for beauty and knowledge. Something inside me never abandoned deep religious aspirations. Great landscapes were part of my choice, like those in the Morvan region, the vast valleyed spaces where fields and forests alternate. For this reason, I left Paris. Despite my solitude, I had exhausted the city's rhythms and movements. In the farm at Chassy, so close to basic things, dilapidated but infinitely great in the echoes it produced of certainty and profound truth, I found a new source of energy and material for advancing my research.

That's why I envied monastic life's gentle regularity, an ordered life from which one may draw the music of silence, as from running water. I often reflect that my youth in exile—not just because of history's hazards, but also my parents' separating—informed my choice of homes, open as Rilke said, to "the Open."

55

This premonition of The Open, toward which Rilke led me, could not be separated from an intuition about death and damage to things, the slow, conclusive erosion of spirituality. In 1934, long years of work were rewarded by my first Paris exhibit, in Pierre Matisse's gallery. But they were already marked by a hint of the world's disintegration. War came, the one we had already foreseen, with its specter of disaster and woe. On September 2, with a certain acceptance of misfortune, as Pierre-Jean Jouve said, I was mobilized and departed for the front. Something that was coming to an end reacquainted me with exile and solitude. However, I returned from the war, having only just escaped death, and my stay in the Savoie region was like a deliverance and rebirth.

Summer of 1940. I recall being agitated by a feverish, violent desire to paint. Painting was the only way out of destruction, the only mountain that guaranteed to save the Beautiful. It was the only possible means of expression. Paris became strange to me. How to accept the obscene intrusion by occupying forces, sufferings of the occupied, abjurations, the dismantling of a whole culture that I had been raised on? I needed mountain air, in Savoie and

later in Switzerland. I felt that in these places, my thoughts could be renewed, reborn, and developed.

But I learned once again that work can only be conceived in fiercely stubborn solitude. The paintings I made then were shown in 1943 at Geneva's Galerie Moos. In 1942, after living in Bern for a few months, I moved near Fribourg [Switzerland], where I enjoyed painting the surroundings, especially the Gottéron valley, and its promontory with strata of visible rock, a real mausoleum of minerals, a sheer, distinct edge on high. The landscape's violence was tempered by the Sarine river that flowed below in its maze of currents. It was analogous to the time we were living through. Ultimately, the period was fertile, putting me back to work, returning me to painting. During these strangled, uncertain years, being immersed in painting was a liberation and deliverance.

56

At the beginning of the 1960s in Rome, on a peaceful day, I lived through another premonition of death. I sometimes tell this odd story in the form of a tale or fable. I left the Villa Médicis to go to an ironmaster's, to whom I had given a restoration job. Barely had I entered the workshop when I saw a bust by Giacometti that seemed to greet, await, or warn me. I couldn't hide my confusion, extreme disturbance, and discomfort. I asked for information about the bust, how it came to be there. The ironmaster explained that a collector had sent it from Paris for a new patina. The explanation didn't satisfy me, and I fell to admiring the sculpture, like a gaping, burst meteorite. I cut short my visit and returned to the Villa, worried and sure to have seen a bad omen.

When I got back, I was told about the death of my friend Alberto Giacometti.

I believe in these secret signs, these calls from afar, and fated coincidences because they tie us to invisible things that must be accepted.

57

Surely due to my Christian belief, I am totally indifferent to society's seductions, the notorious personality cult that the modern world imposes on artists. The Desert Fathers, apostles who should be our guiding lights, promulgate renunciation, an extreme bareness that permits me to reach my interior vision, what I really am. Instead of this, society constantly calls on people, distancing them from themselves, putting mirrors in front of their faces that do not reflect reality. They are mere lies, alibis, and masks. The art market is infected with this kind of gangrene, and a painter's sacrosanct signature is worth more than the painting itself. What absurdity and vanity, when one compares it to the past! How far we are from the old masters' modesty and need for seclusion. For Poussin, signing a painting was the merest formality.

Modern painting hasn't really understood that painting's sublime, ultimate purpose—if it has one—is to be the tool or passageway to answering the world's most daunting questions that haven't been fathomed. The Great Book of the Universe remains impenetrable and painting is one of its possible keys. That's why it is indubitably religious, and therefore spiritual. Through painting,

I revisit the course of time and history, necessarily reaching prehistory, at an unknown time, original in the true sense of the word. That is, something newly born. Working allows me to be present on the first day, in an extreme, solitary adventure laden with all of past history. For this reason I always state that the painter's work cannot be dissociated from his predecessors. Starting from scratch has no meaning if a painter isn't first imbued with the entire history of art, having assimilated it, and starts from there, transfigured by what he is, what he sees and feels.

Painting is something both embodied and spiritualized. It's a way of attaining the soul through the body. It can only be attempted by those who know the magnificent jubiliation of moving a hand over the canvas, preparing the oils, measuring the canvas's tightness, and throwing oneself into color. The intellectual wanderings of Surrealist exercises are contrary to painting. Being too cerebral and jokey can obstruct an artisan's manual labor, and impede the ascent to the soul. Believing that my young girls are perversely erotic is to remain on the level of material things. It means understanding nothing about the innocence of adolescent languor, and the truth of childhood.

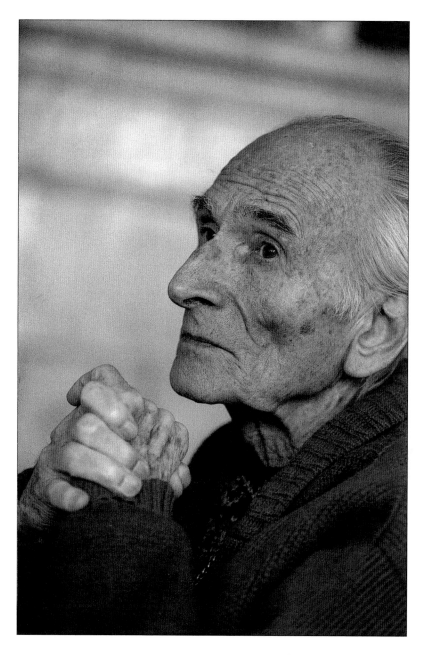

An image from 1999: Balthus often declared that painting was like praying. *R. Gaillarde/Gamma*

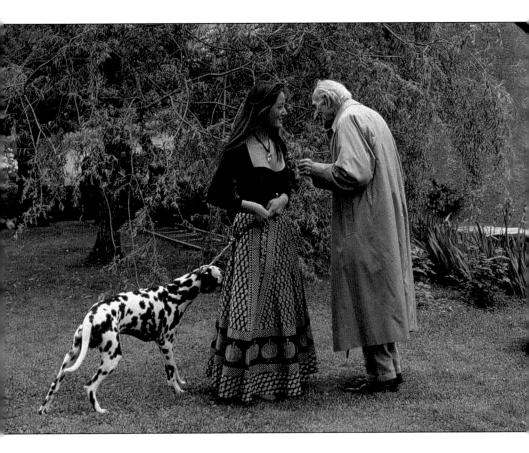

2000: The painter and his daughter, Harumi, understand each other perfectly.

E. Scalfari/AGF/Gamma

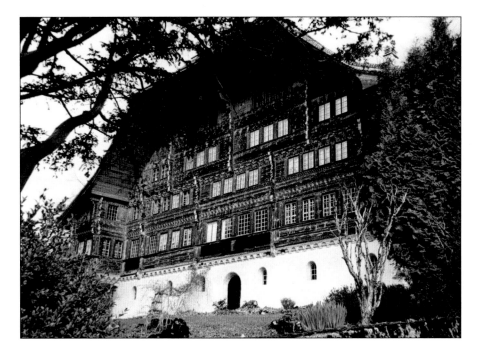

2000: The chalet overlooking the garden. It resembles a Far Eastern temple lost in the Alpine pastures. *A. Vircondelet*

2000: The Siamese cat Mitsou 2 watches from one of the chalet's central windows. The religious sentiments etched onto the facade are reminders to visitors that the human condition is fleeting. *A. Vircondelet*

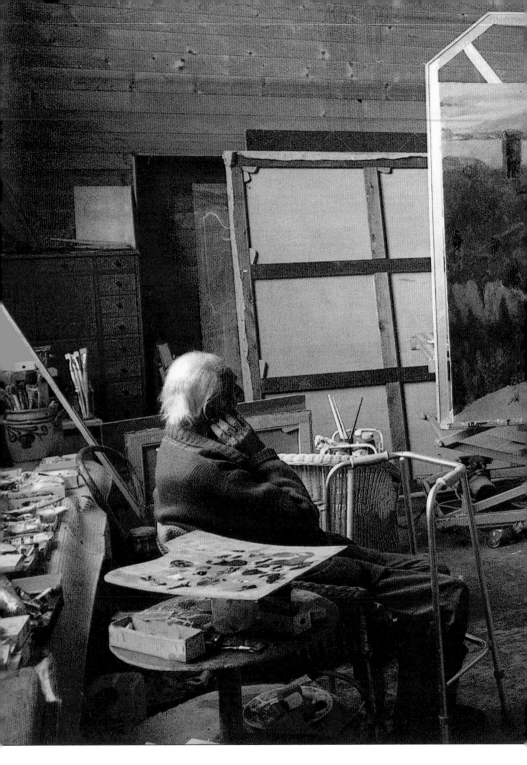

The painter often pauses to meditate in front of a canvas to plumb its meaning.
R. Gaillarde/Gamma

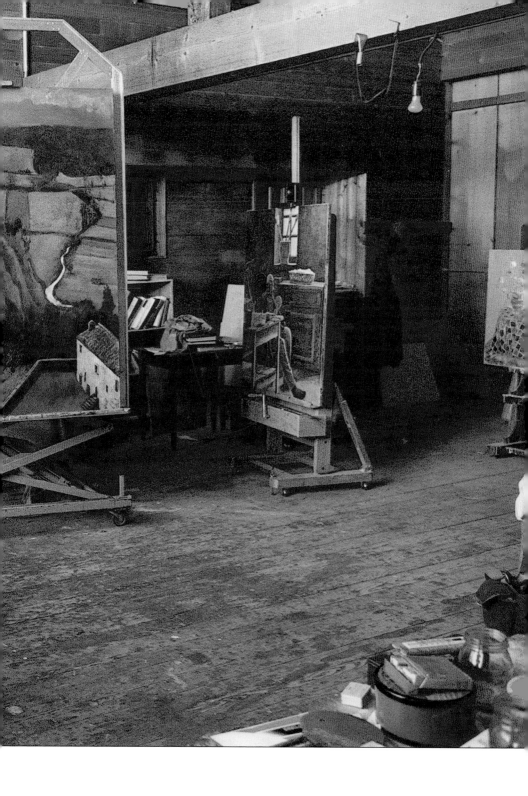

Balthus loved the grand, fresco-decorated terraces of his chateau at Montecalvello, located one hundred kilometers from Rome. A place where art and eternal nature meet, they are magnificent vantage points for the surrounding countryside.
J. M. Voge/Gamma

2000: The faithful dalmatian plays in the chalet courtyard. *A. Vircondelet*

2000: Cushions embroidered by the Countess with images of the house's cats that Balthus often leans against when napping. *E. Adjani/Sygma*

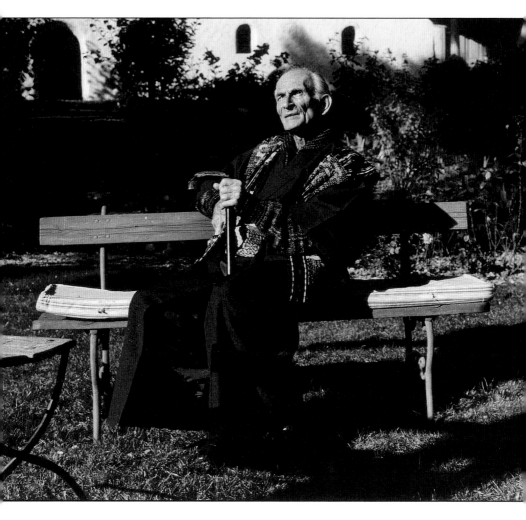

Balthus: a feudal lord in the modern world. Visionary and prophetic.

58

I deeply believe in the genius of painting, which parallels that of childhood. I've used painting as a language without really having decided to do so, because it suits me better than writing. Writing tries to be too explicit and go directly to a meaning. That's why I could never be a writer like many of my friends. Some aspects of my life might be clarified by the present short texts, similar to letters. My son Eustache found a packet of letters I'd sent my first wife, Antoinette de Watteville, the mother of my two sons. All these years later, he thought they were worthy of publication, which he is arranging now. For me, writing can only be in the ellipses, where I express myself; painting conveys this magnificently, sometimes unbeknownst to the painter himself.

59

Pierre Colle, who sold my paintings from the 1930s until his death in 1948, was one of my dearest friends. He was highly informed and intuitive, surrounded by all of Paris's unique creative personalities: Picasso, Dufy, Braque, Lurçat, Max Jacob, Soutine, Matisse, Chirico, Giacometti, and even Frida Kahlo. He dared to show Brassaï's work, putting photography on the same level as painting. He took care of me, and made great efforts to assemble a network of collectors for me. His gallery was at 29 rue Cambacérès.

60

When I see myself in photos from this time, I observe a young man, anxious, solitary, and aggressive. I see much anguish and melancholy. Perhaps because of this, or thanks to this, I acquired considerable certainty about my work. Vanity and conceit played no part in this. On the contrary, it was a way of surviving and advancing, since it's vital to always work and improve in everything. For this reason, I never gave a damn for anyone's advice, and even less for the fashions and mannerisms that were easily discerned in contemporary painting. What mattered was to believe in myself, and bring to light what was obscure stammering and trembling. Work and more work are needed to reach what is most precise about a painting. For painting has its precision, a moment when one knows it is finished, when the painter knows he cannot extend artistic conscience, and the canvas has arrived at fulfillment. At this exact moment, we can speak of beauty.

61

That's why the anguish and worry I discern in my old photos reflect the fear of not attaining beauty, of not having the time to do so. Death didn't frighten me, or dying, except the idea of it coming unexpectedly during work hours. It has a way of stopping everything intended for recurrence, whether seasons, weather, all of nature's cycles, or light. Above all, light. When I arrive at my studio every morning, I am seized by the same fear, the same worry about the light, my interlocutor, that is different from day to day, changeable as life and the wind. It's a painter's necessity, by which he attains fulfillment. For this reason, it's a tragic profession, dependent on the fateful light. One must always grab hold of truth, perceived intuitively, with no time lost on what passes and dwindles. Setsuko and I take a short walk in my beloved Japanese-style garden, in the tutelary shadow of Grand Chalet. Impromptu beauty appears, with the mountains and the little train whose whistle is like a sob.

That's what must be recorded and restored. Only that. For all these quasi-religious reasons, I felt that I was removed from my contemporaries' concerns, which were too conceptual and

abstract. To my mind, God made the world and couldn't have made it ugly or illegible, so He left us an immense field of beauties that must be available to every painter. With such riches, why make ugliness? I've always felt like a depositary of these gifts, responsible for them. One must overcome one's own dejection, suffering, and doubts, and buckle down to the immense job of painting, which is a baptism, an immersion in God's beauty.

62

I'm not afraid of death, but feel an anguish when I realize death will interrupt the completion of what is always a new canvas. I am afraid of not completing it, leaving unfinished something that I brought from afar, of which I may not even be aware. This is distressing above all else. For the rest, I have confidence in God. That's what one calls the consolation of religion. My faith prevents me from thinking that everything will end, that there is nothing more. On the contrary, elsewhere, in other ways, the story will continue. Then I'll see my mother, Baladine, whom I loved so much. I feel death tiptoeing near. Death itself is perceptible, it slips in oddly, indescribably. A strange weariness attacks me, and I must rest and sleep a bit. Little parts of oneself depart, in partial memory lapses, shakiness, and unavoidable, involuntary silences.

But I don't live the last years of my life in decline, a sort of slow, insidious approach to death. No, the opposite is true. Specific rites must be arranged that oppose death's advent. Painting is one of them; making a painting, immersing myself in the canvas and

image; listening to Mozart, who restores energy; drinking tea; and above all, knowing that Countess Setsuko is watching over everything, and thanks to her, the house is a haven of peace and gentleness. Setsuko is my entire life, and her vigilance and love keep me alive.

63

Restoring the Villa Médicis' splendor was a real obsession for me. The project had some relation to spiritual life, a way of preserving life. My friend Fellini understood this, saying: "I see you as guardian of a patrimony in which history has deposited human culture." He was correct, since my long stay in Rome—at first opposed by Academy authorities who argued that traditionally, a member of the Institute was named director—was devoted to the Villa's restoration, to the detriment of my own work. Rediscovering old frescoes, reinventing techniques of painting with quicklime, and furnishing the vast rooms were duties of the Villa's personnel and guests, who also pitched in to help. I had entire walls clouted with shards from broken bottles, to rediscover the materials and matteness on which light and candles reflected admirably. Even my children, Stanislas and Eustache, got involved.

For me, this ardent restoration contained spiritual lessons about life. All of us are responsible for past history, whose testimony must be maintained at all costs, to rediscover the old mas-

ters' teachings, their infinite patience and extraordinary mastery. For me, removing the Villa's cheap finery and vulgar furnishings that had victimized it over the years was a job of rebirth, a form of elevation. To restore its beauty, its translucence.

64

The work I've accomplished over many years—the hours of labor observing nature—was in order to seek in her the secret connections among all things. Unlike the Surrealists, who had an absurdly unlimited faith in dreams, I owe my long, lonely studio days to a way of thinking and seeing that dates back to feudalism and disciplined aristocracy, that only remembers duties. I've always loved to live in magnificent places, not out of vanity but because these places were close to me and my art of living. Chassy's noble disrepair mattered little, so long as it linked me to the most demanding, noblest things. Despite time's violations, Montecalvello's proud grandeur retains a bearing and allure that are a mark of the aristocracy to which I wish our era would aspire. I love the feudal era in old Europe as well as ancient China, where values of faith, respect for nature, and loyalty to one's given talents prevailed over everything else. For this reason, Christianity is a sublime religion, for it brings man to the highest virtues, and neglected values like compassion, kindness, and simplicity in the tradition of Saint John. It's a religion that produces saints. That's why I feel very feudal. This state of mind obliges me to care for others,

and feel privileged to perform these duties. Therefore, I'm proud to have received the Great Cross of the Order of Saints Maurice and Lazarus, from the hands of the Prince of Savoy. I've even framed this decoration in my library.[11]

Sometimes I wear a kimono in memory of the traditions that Countess Setsuko inherited. I was the one to ask her to wear a kimono as often as possible. It was a powerful armor in ancient Japan, a way of continuing history by being its repository.

Is my deep attachment to tradition the reason why I cannot see the French Revolution's developments as real progress and improvement? The events of 1789 helped dismantle the world's status, bringing the advent of a horrid reign of money and the middle class, with petty shopkeepers' values. The Medici kings had an elevated, grandiose outlook, and although I don't share their authoritarian notion of rule, they indisputably encouraged beauty and preserved the arts. In just a few years, cathedral tympanums, royal housefronts, and the admirable religious statues created in the Middle Ages were damaged or destroyed. I found the Villa Médicis in a woeful state of destitution. The roughcast walls and middle-class furnishings had marred everything.

Today's world is an extension of these revolutionary developments. The secular society has forgotten stone, preferring cement and plastic, indestructibly ugly materials and short-lived household goods. It's mankind's tragedy.

11. Italy's Order of Saints Maurice and Lazarus (Ordine dei SS. Maurizio e Lazzaro) was established by Duke Amadeo VIII of Savoy in 1434. Often bestowed during Fascist times, it has not been conferred since 1946.

65

When I met Setsuko Ikeda, she was a young girl, attentive to modern society's developments. Although born into an ancient family whose samurai ancestors were renowned for bravery and nobility, she had progressive opinions about children's education, the role of young girls in society, women's emancipation, etc. At the time, she rarely wore a kimono, preferring modern clothes. Acquaintance with Japanese civilization moved me to wear it myself, and ask her to wear it all the time. Quite often we both go into Rossinière, dressed in our ample silk garments. The kimono ties me to a world that made my youth magic, the proud universe of painting, through the garment's consistency and ritualism. It's a question of "shedding vulgarity," as the admirable author Shitao wrote in his *Statements on Painting by the Monk Bitter-Pumpkin*. Wearing a kimono is a form of asceticism, a true act of simplicity and purification that aspires to nature's truth. Traditional garb isn't gratuitous finery, vainly disguising oneself with a lie or mask, but rather a clue to the old masters' minds. This is proportion and harmony, not vain nostalgia for the past, or even worse, eccentricity. As I stated above, there is a concordance between worlds,

places, landscapes, and people. China and Japan are present at Rossinière and Montecalvello. I see the same ridges in the rocks bolstering Montecalvello and the flanks of my beloved Alps. Grand Chalet's garden, with its little pagoda-shaped summerhouse made of sculpted, eroded wood from the chalet itself, and the mountains creased by the rocks' undulation, make me think of the vast landscapes of Battenberg and ancestral Japan. Apart from the fact that it's an extremely comfortable garment, a kimono makes me travel through time in a way, into the infinity of the universe.

66

Of course I find the freedom granted by the kimono in the practice of painting, but also in the art of smoking that I've always cultivated with nicety. I've always painted while smoking. I am reminded of this habit in photographs from my youth. I intuitively understood that smoking doubled my faculty of concentration, allowing me to be entirely within a canvas. Now that my body is weaker, I smoke less, but I wouldn't miss for anything the exquisite moments of contemplation before a painting-in-progress, with a cigarette between my lips, helping me to advance into it. There are also happy moments spent smoking after meals or tea; the Countess always places cigarettes on a little night table next to the table where I eat lunch. It's a great moment of happiness, what Baudelaire called, I believe, "the pleasant hours."

Sometimes melancholy grabs hold of me, something like regret over leaving this world's noises and light. Mob's whistle from its mountain rail tracks, my dalmatian's barking, and Countess Setsuko's gliding steps. Death isn't only the annunciation of this

irreparable loss. It's also the time when God finally summons you. May He call upon me when He likes, whenever He decides it's timely. However, knowing that a painting is still unfinished reassures me. My Lord, how can I leave when You know that I haven't completed my task?

67

I've often thought that Christianity gave me a bastion's strength, and perhaps that's why I loved fortresses and old barracks with powerful defense works. Christianity's richness is based on the existence of Christ's icon, fragile yet rock solid, divine yet open to human misfortune and poverty.

Today, the world having lost all its signposts, all its pathways, there is nothing left to ward off wicked people, the forces of wrongdoing, and evil geniuses who are inevitably present. For centuries, Jesus' religion gave us confidence, certainty, and fervor to advance and create. How else could I have continued my patient work, painting's deliberate path, when so many others made paintings as if they were rough copies, instead of mirrors of God?

That's why I have the impression that our world is starless, sailing blindly into a completely black night. Our truths have cracks, our certainties have fissures, and our souls are porous as sponges, unable to control and retain certainty. Christianity and the belief one has in it are not just encouraging, but contain a builder's bravery. It pleases me to know that my religion made it possible to erect cathedrals. I'm proud of that heritage, taking it as

a form of grace. Our century doesn't believe in anything anymore. Nor do modern painters, whereas I believe that a painter's work must attain the most sacred things. Attain the forms, designs, and colors that are closest to divine things. Fra Angelico and Piero della Francesca did likewise, approaching God's mystery with complete modesty.

68

People are often surprised that I rarely speak of my brother, Pierre Klossowski de Rola. We have a strange relationship. Today I hardly ever see him, perhaps because our spiritual paths have diverged. These obscure and tenuous ties are a mysterious thing, something I really can't analyze. Pierre was inspired by the Catholic religion, to the point of entering a Dominican order, only to leave later. I believe that his pictorial and literary work are very important for the latter part of the twentieth century. Many of our mutual friends have supported him, recognizing that Klossowski has an exceptional power and genius. I am not, nevertheless, entirely susceptible to what he writes, draws, and paints. Perhaps because it is transgressive work, not luminous enough. The paths I've chosen are more open to God's gifts. Klossowski's work is a black diamond, while I try to paint starbursts, shuddering wings, and children's flesh lightly touched by angels.

That doesn't mean my paintings should be interpreted. They are offered like hymns, psalms, or prayers.

69

I believed in my painting so much that finally, it couldn't be considered as vanity or effrontery. From 1940 to 1954, during my stay in Paris, some people hated me because I didn't play the game of trends in art or aesthetic movements that was fashionable then. I maintained a total indifference that must have angered other painters and gallery owners. This slightly fanatical, romantic distance won me Artaud's friendship; as I've said, he saw a double in me. A brother speaking of his double in the style of Musset's "December Night."[12] The solitude that forcibly followed did not alter my certainty of being truthful and accurate. Instead, voluntary solitude brought me close to the monastic life that had often tempted me; I found it by fleeing Paris for stoic solitude in isolated and ascetic places. For example, at Chassy, there were days of intense work almost exclusively devoted to painting, in the development of a canvas; I entered into a communion with the landscape and my niece Frédérique, who little by little took possession

12. "La Nuit de décembre," a poem by Alfred de Musset (1810–1857), contains the lines: "A poor boy dressed in black / came to sit in front of my table / resembling me like a brother . . ."

of the place, became its "lady" in a medieval sense. Thus at Chassy, I found a total equivalent to my Polish roots and my acquired culture of ancient China. Yet I was in a country place, endlessly rural, amid the soil's presiding spirit with its strong, obtuse weight, surrounded by manual labor, herds of livestock, and the ancient Nevers region's mystery, so removed from the worldliness that my contemporaries enjoyed. Frédérique's presence was enough for me, as she took care of the place, as its queen. In a 1955 portrait, *Young Girl in a White Shirt*, I tried to depict her in royal guise. She had barely emerged from childhood, with her innocent limbs, yet had the hieratic, sculptural power of ancient queens. When I was appointed to the Villa Médicis, of course she followed me to Rome. But Setsuko's arrival in my life made our existence together difficult. Things couldn't be the same between us as they were before. She took the Countess's miraculously sudden entry into my life badly, the way she quickly became my model and lover. I left the Chassy manor house to her, and she lives there still. I retain a strong memory of the 1950s, when I lived with her and painted many of my landscapes. Where I made so many drawings and was perhaps closest to nature's mysteries.

70

One mustn't imagine that because I often say harsh things about contemporary painting, I despise it all. If I deplore its development, lack of skilled mastery, facility and tendency toward abstraction that permits every facility, all its incongruities, I also admire a few painters, particularly Tàpies. Picasso notoriously reacted in a sad and malicious way when he saw Miró's last works. Picasso, faced by the childishness that Miró was producing, sought to bring him back to reason by saying with a smile, "Not you, Miró, not at your age, not after what you've done!"

One could say the same of many painters today. But Tàpies has a depth and richness that vibrates through his canvases; they are seen as flat, monochromatic masses, but they vibrate, moving as puddles of light. It's very powerful and beautiful. There is something Chinese about Tàpies's art. He creates vertigo, motion, and life within black vastness, revealing chaos.

Discussing Tàpies reminds me of Far Eastern painting, the techniques of ancient China and what they have taught me. Shitao

called it, I believe, the need for "a single brushstroke." That is, to go to the root of things with a single line, with a free wrist motion that in its simplicity attains the Nameless, what Chinese painters also call the Universal.

71

I've never felt a real attraction to horror, ugliness, and oddness. All that repels me. Perhaps that's why there was a time when I didn't appreciate drawings by my brother, whose imagination often dwells on what is morbid, perverse, and sadomasochistic. When this whole stock of motifs claims to be close to godly worlds, then I am outraged or completely unreceptive. I am offended by Francis Bacon's bloody pieces of flesh, even though I perceive they are the work of a great painter, like Klossowski's transgressive adventures. With so many beautiful things around us, why strive to ignore them? I sought to paint what was beautiful: cats, landscapes, the soil, fruits, flowers, and of course my dear angels, who are like idealized reflections, godly Platonists. Some biographers and art critics will surely claim (some already have!) that my models are erotically posed, thereby soiling the innocent work I tried to do, in my search for eternity. But no matter! They will also say I played the part of Pygmalion. This only proves they understood nothing about my work. It was always about approaching the mystery of childhood, its languid grace at ill-defined borders. I sought to paint the soul's secrets, the obscure and luminous tension of their partially blooming matrix. I might say it's

about the crossing. The uncertain worrisome time when inno-
cence is total and will soon give way to another age, more deter-
minedly social.

There was something miraculous in this work that led to the
godly. I think Piero della Francesca must have understood what
I'm saying here: a time before time must be discovered and
brought to light. That makes Unity's intangible face suddenly
appear in its unadorned purity, its godliness. I believe I've attained
this in some portraits of young girls, for example *The Moth*, and *The
Young Girl in a White Shirt*. My painting deals with a world no
longer in existence. A submerged world. My work on subjects
turns a painter into a true archaeologist of the soul. We dig, exca-
vate, and clout the soil and canvas, restoring the siltlike consis-
tency of beginnings, and buried time reappears, reborn in the light
of day. Painting is a precise assumption, an elevation just like at the
Holy Mass when the Host is brandished like a golden sun. That's
why painting's only purpose is beauty. The featherlike flesh
painted by some contemporary artists makes their work about the
Fall. It's Luciferian. When it really should be about attaining divine
beauty—or at least its reflections.

72

When I spent time with my great friend Pierre-Jean Jouve, I often attempted the difficult passing through secrets, the penetration into darkness that leads to its opposite, or light. He was interested in my work because we were both in the same regions, the same waters. I understood what Jouve was trying to clarify, as he was deeply attached to perfection. Beyond his work, his life was haunted by mystical callings that were also my concern. I appreciated that he abandoned alliances with Surrealism, just as I have, because it had nothing more to give. Once, we could believe that calling on the subconscious could lead to the revelation of mysteries. The Surrealists did this endlessly, but soon we saw failure and possible fraud in it. Our spirits were commanded by the absolute, not distracted by the artificial trap of Breton's methods. We knew that our lives had to undergo a personal trajectory that no school or academy could teach. This strict solitude was needed in order to advance. I liked Jouve because of his strictness. I often visited him, and we always talked about the same things. He had something endlessly Baudelairean about him. For example, his taste for the duality of flesh and mind, the erotic and virginal body, his will to

ritualize everything, and bring his words into abysslike vortices. He loved my paintings because he found the same quest and duality in them. Indeed, I often felt Baudelairean, because of his dandyism, his heart's aristocracy. My proud solitude at the cour de Rohan, the way I had of always experiencing marginal worlds, and sometimes letting them appear involuntarily, as in my latest painting, which I've forced myself to work on for months and which I may never finish. Where does this young girl on her couch originate? Why is there a guitar at her side, leaning against the couch? What is the dog looking at through the window? Where does the sinuous path lead, like the silvery maze at the foot of Montecalvello? I don't know the answers, and no analyst can explain them. Jouve liked this impossible elucidation, a constant oscillation between man's redemption and suffering. Jouve explained the objective of some poets and painters of the day, like Derain, Miró, and Tápies. He said, "We are unconscious masses slightly clarified on the surface by sunlight." He added that these masses reverberated with vibrations and tensions captured by a painting or poem, and inscribed on canvas or paper. This strange alchemy occurs without rational intervening. I learned from Jouve that the art we produce must happen in unknown regions that the imagination alone controls.

He organized epic evening parties. Poets and artists of all kinds gathered at his home, hosted by Jouve and his wife. These meetings had a certain stiffness, with constrictive demands, and an oracular atmosphere that irritated some, like Artaud. I met many creative people there, like Saint-Exupéry and Albert Camus. All

were soulful writers, highly spiritual. That's because Jouve knew how to nurture his guests. My own spiritual requirements were nourished and strengthened there.

The aforementioned Saint-Exupéry wrote what was perhaps his last postcard to me. It was dated the day before his death, July 31, 1944. When I learned of his death, I thought about the great strapping young man who came to Jouve's home with his petulant wife, Consuelo, whose extraordinarily voluble, South American cooing charmed all the guests. She told cock-and-bull stories, but we all believed them, as she spoke with such conviction. Several months later, I received the postcard, which for a long time was pinned to one of the walls facing my office, until it finally disappeared. No doubt on a moving day. I was attached to it, because it was one of Saint-Exupéry's last messages of friendship.

73

I loved my first wife, Antoinette de Watteville, for reasons that even I don't always understand. Because our first meeting did not happen in an ordinary way, was our love marked by fate?

I met Antoinette when she was barely four years old. I married her in 1937 when I was twenty-nine years old. She inspired me to write beautiful love letters that, as I've said, my sons have recently decided to publish. They believe I had a certain writing talent, although I've never done anything except paint, and don't think I can put one word next to another. It's as if my only means of expression were painting. Nevertheless, I trust my sons. Perhaps the passionate love I felt for Antoinette made me transcend my paltry writing skills? Who knows?

I painted Antoinette de Watteville several times. She appears in one of my favorite canvases, *The Mountain*, that I painted in 1937, the year of my marriage, and in *The White Shirt*, also in 1937. Antoinette appears here with her radiant, fierce beauty. Particularly, the bodily tension that I wanted to depict and made her adopt. At the time, she was a wild young woman, fatigued by asthma, but with extraordinary inner force. She exerted incompa-

rable magnetism, and dominated me almost magically. She had a sort of intuitive understanding of my doubts, worries, and the remorse I felt when I didn't work. From her, I acquired the self-confidence that we've come to share. We both had the same aristocratic rigor—she belonged to one of the most aristocratic families in the canton of Bern—the same appreciation of virtue, which etymologically means a form of courage to progress and to accept poverty in order not to betray, or be swayed in one's commitments and loyalties. But life doesn't always allow us to live out all our commitments. My dedication to painting put me on other paths, near other people, ultimately Countess Setsuko, who incarnates the kind of total beauty I've always been attracted to, that united her to me. Setsuko guides my weakened steps through the chalet, anticipating my wants and requests, holds my arm to get me up to my room, coordinates her footsteps with infinite patience and love to my poor shuffle! She is discreetly preparing to be baptized, which for me is a great anticipation and joy. She will enter the Holy Roman Church that I revere, a further tie between us, surely the firmest one.

74

People's powers accumulate from the power of the works they produce in the course of their lives, and their determination. In 1914, the Klossowski family lost everything; my father, having no idea how to make money, used all his savings to buy Russian railway stock. You can imagine how much we lost! Political events introduced us to exile, the pain of separation, and fixed in our hearts the feeling of abandonment. My parents' interior spiritual energy helped us overcome the losses the family suffered. My father, who loved art so much, managed to transcend the feeling of loss to which our unstable lives as emigrants might have driven us. Art became a form of salvation.

During my childhood, I lived through the experience of redemption through art in a carnal and intuitive way. I knew that art's contribution and the discovery of beauty, which it generated in the heart, could vanquish every misfortune, and ease every solitude. I've always lived with this deep belief within me. It helped me in my peregrinations and wanderings that recall the young Jean-Jacques Rousseau, whose *Confessions* tell of initiatory adventures akin to those I experienced. His trip to Italy helped him better

understand things, advance, and emerge more successfully from the material difficulties of an uncertain life. For me, the labor and tenacity required to practice an art, the long studio hours and need to stick to it, were ways not to lose hold of myself. I always experienced a calling, a vocation. It is something that consecrated me to this life, fatefully leading me to it.

75

My perseverance, fervor, and faith led to spirituality and compassionate relationships with some people. Is it because I am deeply religious that I see compassion as the finest virtue taught by Christ? To have compassion means to suffer with others, but also to listen to them, hear and understand them. The experience of painting has not made me autistic; on the contrary. It's an inhabited solitude, into which the entire world enters joyfully, without exclusion.

I am reminded of the pretty painting that I'd presented to a café waiter for whom I had a lot of affection, by way of my friend Giacometti. It was a small canvas, a still life of a coffeepot. Some years ago, it was discovered in my friend Alberto's estate. Could that mean he never gave the painting to the waiter? I believe in Giacometti's honesty, so I doubt that this could be true. I did regret that the person I gave the painting to never received it. I wanted to extend to him a real gesture of friendship to express a sort of fraternal connection. I wanted to do it discreetly so that he wouldn't have to thank me or feel uncomfortable in my presence. And years

later, I found out that this was not done. I feel great sadness and disappointment. Sometimes a hand extended, the traces one wants to leave behind, sink into the abyss. Like sparks that blaze up and are extinguished.

76

When I think of the years gone by, I recall astonishingly vivid figures whom I greatly admired or abandoned because they didn't correspond to my own concerns. I felt, during many years of solitary creativity, that painters must live a sort of ascetic life, far from clamor, trends, and Parisian ways. I recall Maurice Blanchot and Henri Michaux as figures I respected for their silence, their will to bury themselves in creativity, and refusal to compromise. I appreciated Georges Bataille less, because of his outbursts, violence, and desire to dominate. Yet I saw a lot of Bataille, though I didn't agree with his ideas, the whims and madness he put into everything. Bataille needed to dominate others just like André Breton. Bataille was close to Breton and yet estranged from him because their personalities were too strong to coexist. There was something puerile about his projects, an overdeveloped sense of secrecy that gave him the air of a guru. He would have gladly been pope of a self-created religion, and I couldn't follow him intellectually in his wanderings. At the time I was too independent, too fierce to follow anyone in far-fetched adventures.

The postwar creation of Acéphale[13] fascinated many artists, but I didn't care for its initiatory practices, aimed at trying to fathom secrets. Bataille had a definite taste for secret rituals and all that went with them, formalities, stage direction, and rituals that inspired his work. I wasn't interested in this Masonic lodge atmosphere of eroticism, transgression, blasphemy, and sacredness turned into the diabolical. My brother, Klossowski, was interested for a time in these creative attempts, but we had too strong a Christian imagination to succumb to them. Bataille's personality was tinged with anti-Semitism, as those of us who rejected his theories saw it. Bataille was fascinated by the painstaking rituals that Fascists used to seduce crowds. The will to power truly fascinated him.

I abhorred all this madness, however it was staged. At the time, I sought ways to attain art's mysteries by more peaceful and sensitive means. I never betrayed this vocation for godly beauty that I tried to reinvest in my life. There were no visible interruptions or temporary distractions. On the contrary, I always courted unity. This was granted me by landscape, the ambiguous, dizzying grace of my young female models, the texture of their skins and that of the fruits I enjoyed gathering. Courbet guided me more than the pseudo-erotic adventures and childish efforts of Bataille and his friends. Not to mention the supposedly new paths that Breton wanted to lead us through. Textures by primitive Italian painters, like flesh by Delacroix and Courbet, were sufficient for me. I never departed from them.

13. Acéphale, a secret society founded by Georges Bataille involving his obsessions with eroticism, scatology, and death.

77

These days when I have difficulty walking, and am almost blind, I rely on the good Doctor Liu, my physician and faithful servant, who almost never leaves me, except when I am in the studio and need to be alone, or else with the Countess, whose presence comforts me and saves me a lot of time. She mixes colors and handles many other jobs once done by studio assistants.

I love the moment when we embark, so to speak, for the studio. Leaving the chalet in a little cart for the handicapped—let's use the word—Liu ties a belt around my waist, and I'm bundled up with a traveling rug before we cross the entrance court; the dalmatian comes to greet us, we descend the little hill, cross the road, and arrive at the studio that's warmed by a purring stove, and the sacrosanct smells of turpentine oil, binding material, and paintings. A large picture window dominates the place, casting puddles of light onto the easels fixed on wheels that Countess Setsuko moves gracefully and effortlessly up to my wheelchair. A moment of infinite grace, when I find myself with an unfinished canvas, a painting-in-progress! To ford a river halfway, and live for the completion of a work that's finally accomplished. I've never really

understood how this mystery or enchantment operates, the canvas receiving what I myself didn't know it would. Here at Rossinière, the days follow each other with the regularity of a Book of Hours. Days are marked off by Mozart and sometimes reading aloud by the Countess or Mr. Burton—one of my friends—that allows us to rediscover the great sacred texts, the Bible or *The Book of the Dead*, or a fundamental text like *The Odyssey*. Gently, in this way, the days go by. Always continuing to praise time, and know its measure.

78

My Catholic faith didn't come from my family, since my father was Protestant. Life's vagaries decided the matter. One of my rich Polish cousins, Adam-Maxwell Reveski, bequeathed a tidy fortune to my brother and myself. We would inherit it as adults, on the condition that we converted to Catholicism. My parents gladly agreed. We were raised traditionally, and I must say I've always been glad we were. Even though we never enjoyed our inheritance—because of wartime currency devaluation—I retained the constant legacy of Christianity, and the companionship of Christ. I recall indescribable solitary moments in the chapels of Padua and Siena, communing with early masters and the actual presence of Christian mystery, that I felt carnally. The Catholic religion has helped me to live and withstand suffering, but also on many occasions to understand what is hidden. Religion of the incarnation, it is also the religion of proximity to godliness, a presence that is both palpable and invisible.

Icons and a rosary hang over my bed. A relationship to sacred things nourishes my work, allowing me to enter more deeply into the world's mystery. Artists I loved were never transgressive people. Even

if they weren't believers, their works went in the direction of life according to Christian teachings. I'm thinking of Picasso, Derain, and Bonnard. I didn't spend much time with Jean Cocteau, although we did meet on occasion, but I intuitively knew that his painting was too slight—to be a sacred painter like Piero della Francesca, it wasn't enough to paint chapels. As a fashionable painter, he shone abundantly in high society, but too dazzlingly to be a real star. I like rays that are deeper, more profound. Of course there is more light in Tápies than in Cocteau! Because his death occurred a few hours after Edith Piaf's, Cocteau was cheated of the tabloid headlines he must have expected. Piaf's fire extinguished him.

After I visited these fashionable places, however rarely, I would return to my cour de Rohan studio, more confident about my work as farmer and artisan, my silent drudging and meticulousness. Hours and days had to pass before I could be sure I was advancing on the right path. At the time, some painters' rapid lines puzzled me. In this sense, Cocteau was too systematic and meretricious a painter. Fluency killed his painting. As for me, some friends believed in what I was doing, giving me hope, and reliable collectors who followed my work encouraged me. Without them, would I have continued? In retrospect, surely yes. I had too many proofs of faith to give up, secret supports like prayer and the certainty of reaching a kind of personal truth. Perhaps this was due to my abiding medieval disposition and determination. To always take the high road with respect to earthly things. To ascend with spiritual intent.

79

One of my art's main motifs is the mirror, invested with the mark of vanity as well as the highest ascendancy. To me, it often gives an echo of the spirit's profoundest varieties, in the style of writings by Plato, whom I often read at Rossinière. That's why my young girls often hold them, not only to look at themselves, which would be a mere sign of frivolity—and my young girls are not shameless Lolitas—but to plumb the furthest depths of their underlying beings. Thus my paintings have many layers of meaning, vanishings in the canvas, so to speak, that duplicate its story, confessing their unfathomability. I don't want to begin any exegesis of my art that, as I've stated, "works" unbeknownst to me—I often don't know where the brush is heading and along which path it is moving; all I know is when my hand cannot avoid the single brushstroke described by Shitao.

A more technical reason explains the presence of mirrors in my work. I've often been photographed with a mirror near my eyes, because I don't see well. That way I can see a reversed image of my work, and discern any perspectival errors. It's an old trick used by Piero della Francesca, who was in many ways one of the

founders of perspectival painting. Therefore I never considered the mirror mainly as a symbolic image. That would be a picturesque reference, quite foreign to me. Painting is part of a distant, secret domain, where one cannot insert a significant object like a cat or mirror without entering into the particular, or explicit, aspect of a canvas. Thus a mirror might be the symbol of an attic window, open to dreams and imagination. That's not what I intended. The mirror imposed itself as one inherent element of a painting. Some of my young girls have mirrors; they gaze at them, and the painting takes off unpredictably. It's up to viewers to rediscover the diverse strands that are unconsciously and obscurely gathered therein.

I believe that mirrors and cats help in personal crossings. In any case, a painting isn't the arrangement or staging of a story. It is what personal memory imposes, which a painter as a good artisan and journeyman must always obey. That's why I abhor calling an artist a creator. Instead, he obediently executes what is imposed upon him. Cats and mirrors are added not wherever I like, but as a personal necessity. My experience with cats proves this. They are the becalmed presiding spirits of our home and must be allowed to operate in safe, contained quiet; they live as kings in the chalet, even if I once did call myself the King of Cats!

80

I greatly admire Delacroix's power, which comes from his ability to grasp reflections of things and captures carnal mysteries, glances, and motionless time. The Orientalism attributed to him is free of anything picturesque or of exotic knickknacks of the Pierre Loti variety. For this reason, his North African paintings aren't essentially Oriental depictions, but on the contrary, reflections of an elsewhere. His *Journal* tries to express this element that makes him a modern painter. Baudelaire understood the extent of the aesthetic expressed in Delacroix's *Journal*. Because the spirit of things must be reflected on canvas, it isn't necessary to paint in the field. I must reiterate that this new approach to painting paved the way for twentieth-century painters. Delacroix's project was to grasp the universality of people, things, and the world.

My constant study of early Italian painters and once-frequent visits to the Louvre have strongly marked me with images added to my mind's immemorial crucible. My work constantly dips into it to rediscover landscapes, poses, and faces in other guises. Thus a Bellini courtesan—holding a mirror, moreover—a Lauwet engraving, Lorenzetti's *Peace*, or Poussin's *Autumn*, come to life in other

guises in *The Fine Days*, *Cat with Mirror*, and *The Cherry Tree*. Everything is in everything else, through a strong current of flux and secret exchanges. Unlike contemporary painters, one must have a minimum of historical art culture to achieve this. There is no painting without memory, or in scorning a past that I find nourishing and fruitful. When copying a master, one is struck by his unadorned quality. It took me years of work to reproduce the chalky matteness of Masaccio's and Piero della Francesca's paintings. Among my contemporaries, I feel that Picasso was the only one who merited the title of great painter; he understood self-unawareness and felt humility before Delacroix's genius. Like myself, he lamented when making copies of Delacroix; he would speak of himself in the third person, whining, "What a tragedy! Picasso knows nothing!"

Knowing means always knowing more. Always going further. And with infinite, silent patience, being determined to remember the pathway.

81

Going back over one's past is necessary, but it must be done
lightly. Just as the first leaves of springtime give green tulle to
branches that were thought dead. My long life has accorded me
signs of friendship, goodness, and love, as well as joy from friends
and sights that moved me. I had the great luck to meet everyone
then at the center of the world. I retain dazzling memories of some
artists I met and with whom I spent time, although my tastes
always inclined me to solitude. I recall Albert Camus as an
extremely nice man, and observed his constant anguish and con-
flict, although his good nature and wide grin made people forget
his dark side. Just before his fatal accident, he sent me one of his
books—I think it was *The Fall*—inscribing it in premonitory fash-
ion, "To you who make the springtime, I send my winter." In
1948, when we worked together on *State of Siege*, I noticed the
dark light in his gaze, sudden melancholy, and anxiety attacks that
worsened with time. He was devoured by life, by something he
couldn't control that worried him immensely. I vividly recall our
collaboration. Thanks to having designed the sets and costumes
for this play, I met Paul Éluard, Jean-Louis Barrault, and André

Malraux. These were intense times, and Albert Camus was able to arrange and organize things. He had the energy of a great theatrical manager, with the motivational power to master the art of directing actors. I was distraught when I heard about his death in a stupid car accident.

Many friends have been erased from my life in this manner, but I retain lovely images of them, which never leave me. For Camus, I was the one who knew how "to make springtime." He admired my work's obstinate fidelity in noting beauty, unaffected by trends or random innovations. I had confidence in my beloved Italians, Poussin's splendidly rigorous unity, and Courbet's accomplishments. Of course it wasn't a question of copying them, but starting with them, to first attain their level and then advance to an open pathway. Antonin Artaud, who often hated me for psychological and psychiatric reasons while nevertheless considering me his brother, said that I painted "lights and shapes first of all." He was partly correct. I've devoted my entire life to reaching the sacred glow that halos twilight and dawn, a lactant light of creation that I think I attained in *The Moth* and *Young Girl in a White Shirt*. Aren't light and shapes a godly adventure, an advancement onto sacred high seas? Perhaps that's why I've preferred mountains and valleys, rather than the sea, which I've depicted only rarely. The peaks are those of my youth, motifs from my art completely devoted to praise. To light's crossing over.

Our life is marked by trials and tensions, but also by indescribable moments of grace. I always aspired to Bonnard's example of joy, even while experiencing its vanishing and neglect. For exam-

ple, the death of the first child that Countess Setsuko and I had, who died so young in the suddenly golden light of the Villa Médicis' Turkish room. The Countess recalls it as a distressing revelation and assumption of our dear child, amid radiating light. Perhaps that's why we're such fervent believers, because of the certainty of light and its revelation that I've often worked for, trying to grasp its dazzlement. That's why painting is a state of grace. No one takes up painting with impunity. One must be worthy of it. Accepting of the obligatory sacred injunction. Just listen to the brush's dull, dry, and sweet sound upon a canvas stretched as tight as a drum, and approach the light. The requirements are unique, insatiable, and tyrannical. Sometimes I've retracted a subject, starting all over again when I thought I had finished, with everything in place, completed, and with everyone around me pleased. This happened with *The Turkish Room*, and the third version of *Young Girl at the Mirror III*, which had to be begun anew because the painting didn't hold together. It fell into pieces as if the light didn't support or sustain the painting.

The life we lead at Rossinière is entirely devoted to painting. The only way for me to live is by accepting the gift of painting. There is something monastic in this retreat. But the retreat is open to others. What joy when Philippe Noiret visits us, or when Bono, who I believe is a singer in the rock group U2, provides his gusto, exuberance, and kindness! Conversion, everything is conversion.

82

I realize that all the people I've known and loved, my family, have a quasi-mystical relationship with life and the world. How could it be otherwise? It is as if one accepts a court summons, with no opportunity to withdraw. That's the way I think of my great friend André Malraux. We didn't share the same life choices, but his ardor, violence, and veracity transcended him. He had a cutting view of the world, in the sense that it cut to infinite extremes. His skill at synthesis made him tally up civilizations. He found a Reims Cathedral angel's smile in an Angkor Buddha. For him, artistic productions weren't tied to a given historical time, but linked by an invisible wire across the universe; he used to say that one could rediscover the same vibrations in masterworks of early Italian painting and Chinese painting from the Sung dynasty. I shared the same belief that everything is in everything. Thus, on several occasions, I've depicted Montecalvello's peak as Mi Fu or Huang Gongwang, fine Chinese painters of the great Sung dynasty, might have done. The landscape's "wrinkles" are the same. I've always pointed out this analogy, which seemed obvious to me, starting with my youth in

Beatenberg. China was there already, in the Alpine heights, clash of rocks, and flow of fir trees.

Malraux was a man of enthusiasms, and although he didn't believe in God the way I do, he was nonetheless deeply religious. He venerated art for its inescapable proof of man's greatness in relation to his mortality. Which convinced him that art was life-giving, a real antidote to death. Our understanding came from this shared certainty. I've always stated that when faced by the universe and the human condition's absurdity, one must assume a praying posture as the only way to glorify life. My only definition of art is that which consists of celebrating, singing, and accomplishing beauty. My young girls surpass the mortal state; they exalt life through the firmness of their flesh and the light that halos them. It's a way of sublimating one's mortal destiny.

In 1967, when Malraux wrote his *Anti-Mémoires*, he was in a state of mind close to my own. I haven't cultivated any silence about my life, which nevertheless lacks novelistic, spicy events; I long refused any televised interview, and will not now indulge in some sort of outpouring that would seem highly indecent. Malraux thought the same way. In Rome, he spoke to me at length, when he was writing his unique memoirs. There was no question of chronologically expressing intimate confidences, but rather a secret, abrupt, and unsure dialogue with himself, as well as what was close to him, in history and art. I'd like to recall the method he often described in his hoarse deep voice in garden walkways bordered with high boxtrees of the Villa Médicis, of which he named me director. What I am whispering here is nothing but whisper-

ing, words pronounced in a minor key, as if one mustn't speak too loudly on the eve of my death. The days are numbered like so many happy moments snatched away from death, the stilled easel, the unfinished canvas, but with the simple lucidity of old age, the clarity that only seeks to recall certain facts, atmospheres, and moments. These are necessary to keep one alive.

83

The Countess always says that the Rossinière chalet resembles a Chinese house. The omnipresent wood creaks on the floors and walls. The spare series of rooms creates a sense of freedom. I love this place because it makes it possible for me to paint. It is both open to the endless mountains and closed. Indescribable moments of joy are further bewitched by Mozart, whose notes drop inside the chalet, spread outside the windows, and disperse in the valleys. Next to me, Countess Setsuko paints her cats and still lifes and interlaces countless flowers onto cashmere surfaces. Starting from when we lived in Rome, I encouraged her to paint. She needed lots of encouragement before she decided to do so. She is talented, with a minute way of painting reality that owes much to her Japanese origins. Sometimes she enjoys illustrating Japanese tales, old traditional ancestral legends. When our daughter, Harumi, was a girl, she fashioned little puppets and drew stories in bound albums just for her. These can have an unimaginably important influence on young minds. I'm thinking of the ones my mother gave me, especially an album in French of *Struwwelpeter*, or *Shockheaded Peter*, a famous nineteenth-century tale about a frightful child, somewhat

like Sophie but even more cruel and surreal.[14] I adored reading this picture book at the start of the 1920s, and I retained traces of it in my future painting. I've often stated, and still say today, that I paint as I saw things earlier, in my childhood. There's no doubt about it, and resemblances have been pointed out between old legends and some of my paintings' motionless settings, like my illustrations for *Wuthering Heights* or my paintings *The Room* and *The Children*, as well as *The Red Fish*. Highly eloquent traces can indeed be found. My sons circulate a little story, which might originate in children's books, droll and cruel at the same time. They claim, although I never really said it, that on coming home from school one day, they told me they had to paint a motif for homework. They say that I forbade them to draw, threatening to cut their fingers off. This delightful episode about a "severe father" makes me smile. A childhood memory, indeed. How far we were then from today's sterilized children's books!

14. *Les Malheurs de Sophie (Sophie's Misfortunes)* by the Comtesse de Ségur (Paris: Hachette, 1864) is a children's book about a naughty four-year-old girl, with episodes of cruelty.

84

The homes we've chosen have represented hidden, obscure signs of providence. That's how I think of Montecalvello. We visited more than eighty ruins, but no single one was decisive. Then one day we discovered the old stronghold, perched over its feudal moat. There it was, our home, where we wanted to live! But Montecalvello was not yet for sale. It was a folly, with paths on different levels and everything in ruins, but we knew it was for us. We stopped looking, and one day Montecalvello was put on the market. We planned to live in it after the Villa Médicis, and had major structural and decorative renovations made, in the style of those I'd had done at the Villa. I uncovered frescoes, and found a sky-blue whitewash despite the building's feudal aspect. We furnished the château in a spare style, with dark fabrics and furnishings, to better contrast with the elegant architectural ensemble. The climate, however, prevented me from staying in Montecalvello. My doctor recommended drier and cooler air for my lungs That's how we came upon the Alps of my childhood. Once again, providence kept us under its protective wing. The chalet wasn't for sale when we discovered it, but the Countess knew it would be her home. She

immediately declared that she wanted it. This was no mere caprice, but certainty that this was her home; a recognition of a place she had already lived in or visited. These signs can show that a house is for you. I bought it by swapping some paintings with my dealer, Pierre Matisse. Thus, Rossinière cost me the following canvases: *Montecalvello*, *Sleeping Nude*, two versions of *Standing Nude*, and *The Painter and His Model*. I regret nothing about this trade. It allowed me to anchor myself in the landscape of my youth, to rediscover old feelings, a special light, with the impression of having returned. It was as if I'd never left the preferred region, with which I had great affinities. It was a way to return home, to the memory of Baladine and my adolescent excitement, the childhood thrills that I'd never abandoned, but which I found here to be even stronger. Intact.

Thus goes life. One thinks that one is leaving home at a given time, but the trip away from an identifiable world, instead of distancing you, puts you back where you started from. In a sense, the more one goes away, the more one returns. Trips to Italy and my discovery of Piero della Francesca linked me to my childhood region, and the imaginary elements it inspired. At Rossinière, we relish a calm consisting of silence and work. A way of life that Marcel Proust might have called "time regained."

85

My work entered the French national museums' collections during my lifetime because Picasso had bought the painting *The Children*. There was a secret complicity and friendship between us, not boisterous or flaunted. Yet our approaches differed: Picasso's painting multiplied diverse and opposite experiences, whereas I preferred to remain with the same obscure adventure. My investigations of childhood's marvels and secrets interested him. He covered me with compliments so outrageously flattering that I've forgotten them all. Picasso liked me because I was different, enveloped in the solitude I found necessary for my work.

It was in 1948, I recall. We had met in Golfe-Juan in 1947 and saw each other again in Paris. I felt close to him because we were both obviously guided by interior necessities that would not let us abandon our convictions. He had changeability and unbridled curiosity; I had my personal quest, fidelity, and silence. There was something deeply religious about Picasso, or rather ritualistic. Something solar and Greek. My state of mind was darker, more aggressive.

I recall paintings I made in 1935 of Antonin Artaud. When

Artaud returned from Rodez, totally possessed by madness, he accused me of having portrayed a part of himself that he loathed. He wrote to me about "your terrifying subconscious."

I understood that Artaud was rejecting himself, and my hand had only been the guide. My hand had just reproduced what I saw obscurely, surely unbeknownst to myself. I was sure that one can only paint with a fierce tension that approaches truth.

86

I was sixteen years old in 1926, when Rilke died at the Val-Mont sanitarium. No doubt, his secret influence reinforced the somber and skittish personality I then had. With Rilke dead, a sort of tutelary protection disappeared. My mother had separated from her husband, my father, Erich Klossowski de Rola, for whom I felt too much admiration and filial love to allow my mother's companion to replace him. But Rilke showed me nocturnal paths, giving me a taste for slipping through narrow passages to reach The Open. At age sixteen, I was already devoted to painting, certain that I couldn't do anything else in life but paint. Everything would be linked to that. Early on, I understood that everything had to be remade and invented; remade in the sense that Jouve spoke of everything from the past, and invented in the sense of unveiling, bringing a new and naive perspective. I was chosen for something vast, noble, and ambitious that no academy, school, or modern movement could give me. I went into painting with a predisposition of youth and sincerity, an unknown region that I knew was not all jubilation and felicity,

but also included doubt, anguish, and pain. I never hesitated to start a painting over again, even if I'd believed it was finished. My deliberation wasn't a sign of perfectionism, but a way of approaching truth that is glimpsed, inferred, and hunted down. The modest life I led at Chassy often impelled my sons to ask me to produce more. As youngsters, they believed that producing more would allow us to live better. I smiled at this naïveté, so different from my own ambitions. Of course, painting does not come from business or trends, but a ferociously demanding personal adventure, whose result is the appearance of unutterable beauty. Above all, it's mystical work. Otherwise why would a painter accept setbacks and poverty, and devote all his time to sublime suffering? Devote is the right word, as a painter's work deals with the sacred. Without this spiritual dimension in the company of mystery, it would only be fit for random adventures and tyrannical fashion.

I always felt that my paintings were incomplete, that there were still things to be done, to the point where the Countess often wished to snatch a painting away from my desperate habit of repainting. Although I've reached the point where I am given much praise, I feel without false modesty that most of my paintings are total failures. I've already said as much. It's because I find so many things still lacking in them, unattainable yet foreshadowed. One day or another, they must be abandoned. This abandonment or desertion happens with a sort of despair. The resulting painting is experienced as another crossing, another way of reaching the

foreshadowing, the intuition of beauty that Piero della Francesca, Poussin, and Courbet achieved.

The word crossing [*passage*] included in one of my painting's titles, *The Passage du Commerce Saint-André* (1952), may be a sign of my strivings. It's a question of crossing, or passing through, in order to reconnect.

87

A painter always uses visual acuity. It's a question of going far-
ther than what reality displays, although what is "farther" is also
part of reality. A keen gaze is essential so that one never stops look-
ing, being vigilant in visuality. That my eyesight is now weak
hardly matters; what matters is firm internal vision. That way,
things can be penetrated to make sure they are alive, with unimag-
inable spiritual richness. That's why I believe that painting is
essentially a religious adventure. It's stupefying that Mondrian
abandoned landscapes and his admirable way of painting trees, pre-
ferring multicolored little squares. Intellectualism and worldly con-
ceptualization finally withered painting, bringing it close to
technology. Look at the Cubists' strayings and Vasarely's op art.

The infinite patience required to paint fragile petals or languid
cats and young girls is unrelated to the rush of modern life. People
and things have been betrayed by the unfortunate habit of suppos-
edly having the world at one's grasp by turning on a television set.
Sometimes I ride through my canton's valleys in an old-fashioned
barouche. The horses' slow trot gives me time to see, and dwell in
a human dimension. How can the grace of what is "almost

attained" be grasped and accomplished amid speed and noise? It's not a question of castigating modern life, but rather being faithful to one's heritage. A painter's magnificent vocation, his fateful destiny, one might say, is in harmony with earth's song. One must feel the tremor of things, and the atmosphere of obliquely slanting light that expresses the history of time on different interconnecting levels. It's basically religious work, whose result is exultation in the world's vastness and godliness.

As I've stated before, I pray before standing in front of a canvas and beginning the slightest brushstroke. The Virgin of Częstochowa, who appeared in my ancestors' region of Poland, watches over me gently. Her Magnificat, sung at the moment the Angel appeared, is one of the most powerful, fertile, and creative hymns of renunciation in favor of religion. Mary sings, "My spirit hath rejoiced in God my Savior." Painting must be similar to this apparitional scene. Make the world's soul, childhood, and youthfulness spring up. And its light.

88

For me, Alberto Giacometti was the most charming and adorable of friends. In my studio, he presides—not by chance—over my paintings' secret changes and slow developments. His photo is behind my armchair, exactly in front of the large easel, seeming to watch over me, recalling the long conversations we had, during which we sometimes disagreed.

Giacometti thought that painting could be an inexhaustible way of knowing mankind and nature. That's why he returned to the subject of the face, after his Surrealist period. André Breton never forgave him for what he saw as a betrayal. Giacometti persisted. We were allies in the desire to penetrate the mystery of a body, face, and flower. At the time, Surrealists despised this way of painting. For them, everything was played out elsewhere, in hallucinations, automatic writing, and pretense. Giacometti's approach had something religious—intensely sacred—and that touched me deeply. Breton told him, "Everyone knows what a head is," sweeping away Giacometti's drawings with the back of his hand. Alberto replied with moving humility, "Myself, I don't know!" Yet his drawings attain profound truth, eliciting graceful moments and

moods from models. He combined the sublime rigor of the ancients and vividly fleeting emotions. Crossing and eternity were combined. How could André Breton not have perceived this intensity?

Giacometti had a fervor, a feeling for friendship, and fierce generosity that made him shun cliques, trends, and all the intolerance that raged in the 1930s and '40s. His simplicity and lordly nobility charmed me. I miss him greatly.

89

I was unique in never giving in to temptations toward abstraction or Surrealism, which meant that I was disesteemed by André Breton and the abstractionists. But this never displeased me, my Heathcliff side taking care of the rest. Art dealers and galleries almost never contacted me, as I was considered too skittish and gloomy. At one time, I despaired under the weight of so much work and energy, and my despair resulted in silence and solitude. I didn't give in to abstraction, because I think I bordered on abstraction while doing figurative painting. I tried to attain my design's interior architecture and secret structure within a canvas's strictly fixed limits. Look at my Chassy landscapes, a farm courtyard, and the different levels of a landscape with alternating fields, open and plowed. Or a young girl looking at a landscape through a window. The paintings' organization is linked to abstraction. In Cézanne's work, the point at which figurative and abstract art intersect is obvious, and I don't see Cézanne as only a figurative painter. Through simplifying power, he arrives at an essence of his design's strong internal lines, which are no longer like a reproduction of nature. At one point, abstract painters laid down the law, without

bothering to understand Cézanne's pioneering synthesis. I admire his way of reinventing the world according to profound mathematical principles, without ever forgetting the old masters' advances in this domain. Piero della Francesca had already understood the structural organization that led to abstraction. An internal alchemy. This should inspire painters to be more modest and humble.

90

My friendship with Claude Roy dates back to the 1960s, and he wrote a book about my art some years ago. He has the modesty and lordly simplicity that I look for in artists. I enjoyed meeting Roy, as he had an analytical accuracy and insectlike quickness. Immensely learned, he could make connections between things, and understand the links I've mentioned between Far Eastern and Western art. He was an amateur of Chinese poetry and we had many refined conversations on the subject. One day when he visited me at the Villa Médicis, we drolly looked up the article on Balthus in a dictionary—the *Robert*, I believe—and laughed heartily at the definition; my painting was described as "glaucous" [*glauque*]. What could they have meant by that? Insofar as *glauque* means "blue green in color," we didn't see any connection. Was the word used in its moral meaning, namely "perverse, dubious, and steeped in a shady world"? Of course, that's the way the adjective was used. This nonsense about my painting made me smile. I secretly noticed that it wasn't entirely disagreeable to be thought of in this way. The young girls I've sketched and portrayed, including the willfully scandalous *Guitar Lesson*, can be seen as revealing

compulsively erotomaniacal behavior. I've always refuted this, see-
ing them as angelic, heavenly images. But the worlds of some of my
friends, from Artaud and Jouve to Bataille, are not entirely inno-
cent. These friendships were not fortuitous. From there, it's possible
to imagine a relationship between their worlds and mine. In truth,
I believe in the profound duality of people; my requirement of work
as the byword of a painter's task has something religious, ascetic,
and even Jansenist about it. My fierce solitude, and what Jouve
called my "skittish disdain," make me think of the legacy of a Don
Juan permeated by the absolute and ideal. There's nothing glau-
cous or pernicious in this ambiguity. Only shared amounts of
desire and suffering. When I speak of angels and the troubling
grace of some of my young girls, don't forget that the most daz-
zlingly radiant and glorious fallen angel was Lucifer.

The adolescent agitation of my young girls' bodies reflects an
ambiguous nocturnal light along with a light from heaven. How-
ever, I believe that my paintings' repercussions are neither those of
a cynical Don Juan, nor examples of the work of a pious angelism.
Like Byron or the violent, unyielding protagonist of *Wuthering
Heights*, I sought traces of pure nature in shadow and light.

91

For the painter, light is elusive, tyrannical, and always desired because it irradiates the face, making it into a sublime heavenly body. In all my work, I've tracked down light's mysteries in the cour de Rohan from the view out of my studio window to my rediscovery of Colette's face, as I saw her and as she was, self-illuminating, a soul radiant with light. Her portrait watches over the Countess and me every day, as something that went beyond the painter's work, unbeknownst to him, and arrived in an obscure, mysterious way. In 1993, the Countess bought the painting I'd made in 1954, *Colette's Profile*. Colette was the daughter of a Chassy stonemason who worked for me. Henceforth the painting has always been in our sitting room. It's one of the rare paintings that the Countess bought back, but it's highly tutelary for us. A form of interior, spiritual, and angelic light is captured in it, radiating like a monstrance when it's time for coffee, tea, naps, and quiet chats with friends and family. Perhaps that's the key to a painter's work, found by attaining the light that is so difficult to reach, that demands the utmost concentration. I've always sought to understand something about light, to retain its energy, to inquire how it nourishes everything,

and how we can keep it alive. For one must paint invisible, vibrant air that structures everything; that's what must be grasped in order for a painting to exist. Everywhere, light and air have their invisible weight, whether aslant or facing front. It can be in the full-length portrait of Derain or the fevered, risky, and pathetic flight of the moth in the painting of the same name. A painting consists of reverberations of light and air that become its main subjects.

92

When I was five years old and my father socialized with all of Paris's extraordinary new and intelligent minds—from Maurice Denis to André Gide—did I know that I was acquainted with those who would revolutionize painting and become what have been rightly called painters of light and air? I'm thinking of Cézanne's lightness, Bonnard's transparency, and Monet's accomplishments with light. I recall that in 1913, my parents took a trip to Tholonet in Provence. We lived on a farm next to a certain Mr. Rey, who had been one of Cézanne's friends. During conversations, I heard a word repeated, "Cézanne, Cézanne." I didn't connect it with painting, but it echoed so strangely in my imagination that I've always heard the name as a magic spell. "Cézanne" sounds like "Sesame," opening a world I didn't know but to which I was summoned, giving me access to an infinity of emotions.

Bonnard was a family friend, and my father had affection for him, rightly so because he was always loyal to our family. When the First World War was declared, we had to leave Paris, and my parents went bankrupt because of my father's bad investments. When our belongings were dispersed at auction, Bonnard bought some of our

personal items to return to us. Bonnard did not guide me in painting, but he meant a lot to me because of his kindness to my brother and me as children and the attention he paid to my first works. I've always respected his accuracy in painting that had nothing to do with vulgar realism. Yet he managed to convey the essence of things, the characteristics of snow and frost, thrushes shivering in winter along paths laden with the snow that he painted like no one else.

One day when I was a small boy, our family visited Bonnard at Giverny. It was a bustling village, with painters inspired by Claude Monet living there, and it was impossible to take a step in the village without seeing easels planted at random. In the afternoon, Marc Bonnard came to tell his father that Monet had just arrived unexpectedly. Great joy was felt throughout the house. I recall an impressive old man with a big white beard that greatly intrigued us.

I was steeped in this era, rich in the rebirth of art, nurtured by France. Born under these stars, how could I not have been personally motivated to paint? As a small boy, I experienced the moments of peace and joy that Monet and Bonnard captured so well. A background of war and forced exile added emotions of loss and absence, promoting a fear of broken ties and the upsetting notion that everything is transitory. However, I must admit that my childhood was happy, cradled by Baladine's grace and my father's grave, cultivated authority, and later by Rainer Maria Rilke's vigilant attention. I never wanted to lose my ties to it, and on the contrary I persisted in making them stronger. In this way, I've never left my childhood, and perhaps that's why I've painted flowers and budding young girls so tenaciously.

93

I usually say to those who ask me about old age or the spirit of childhood, "The best way not to fall into second childhood is never to leave childhood to begin with." Advanced age is not an acute, painful problem for me. Of course, it isn't particularly easy to accept one's eyesight worsening and how one becomes dependent on others to climb the stairs and get to the studio.

I admit that sometimes when I urgently need help, my voice thunders through the chalet's wooden walls. Life is still worth living—seasonal charms make it so—the daily marvel of another day snatched from darkness, and a walk in any kind of weather with the Countess on my arm. At this time of my life, I've reached a silent and essential period characterized by an apparent deterioration of body and activity. But it is, in fact, an intense, vast, and truthful period. Every hour and minute is lived with an inexplicable sense of fullness, in which things seem restrained and appeased, if not totally resolved. The sole remaining desire is to paint, still stubbornly hounding me to continue a canvas-in-progress to the limits of my strength. I'll go on until God decides that I should join Him. Will I ever finish the canvas I work on

every day? It will be completed at the deliberate pace of all my paintings, obeying the secret mathematics that guides it, since in some way God does guide the work. No rush motivated by my fleeting life can hasten my canvas's scrupulous development. Sometimes there's anguish at the idea that the canvas won't be finished, as if any of my canvases ever was. If not finished, at least worthy to leave the studio and join the others. But I quickly return to the serenity that I'm inclined to.

The canvas will go where it must.

The Countess is a major contributor to my peacefulness of mind and soul. Her presence fulfills me, consoling me for all the loss and misery I've had to accept because of old age.

Preserving as long as possible the wonderment of days and changing light.

94

Windows are a favored means of grasping light and its changes. I'm told that our chalet has over one hundred and ten of them, but I've never counted, preferring to rely on hearsay. I've painted many of them, expressing the wonderment at the world that I still feel on looking out at the scenery I've seen: Chassy, Champrovent, and the cour de Rohan. Not Rossinière, but that's a separate case I must explain again. Perhaps the open vastness of the En-Haut region is self-sufficient and doesn't need to appear on a canvas. I'm not sure. But my young girls are in front of windows, with fruits on the windowsills, and the mountains that mark the landscape establish the world's breadth, The Open that Rilke spoke of, an Open onto the universe. A huge construction site that a painter has in front of him, whose source and center must be found. My landscapes emerge directly from window recesses to take over a canvas, making them join an "itself" that's faraway and profound. I've always tried to paint the obscure, mysterious return of things to their vertiginous center. Had I focused only on a given land-scape's beauty, I would have been caught in the exotic or pictur-esque, figurative art's worst trap. But the quest is elsewhere,

emerging from the soul and returning to it. This gradual alchemical work—impossible to explain in words—must change a landscape into its opposite, a secretive aperture. It's impossible to explain the changes of desire that bring us to a first dark mythic place, forcibly opaque, to which we nonetheless aspire. In this way, to paint is to try to attain the world's depth. I've often used techniques drawn from the early Italian painters (effects with lime, chalk, and wax) to reveal the progress toward depth and a memory from time out of mind. To go toward The Open, to approach and sometimes attain it by snatching deferred moments, and then return to passing time.

95

My trusty Italians' tried-and-true techniques are best for expressing this passing. I tried to translate a certain state of weightless suspension into painting, what I call deferment. *Dream II*, painted in 1956, contains a golden flower like a torch, crossing a sitting room where a young girl sleeps, carried by another, more diaphanous woman like an ancient vestal. This flower is typical of the internal method I've always chosen. It's about revealing the fleeting instant, the dreamlike crossing to secret things, a certain detached time when things take on other meanings, which the painter does not seek to explicate, but to show.

How to manage this? How to reveal a moment, showing it, one might say, in its fullness, juiciness, and opaque power? I admire the early Italian painters' matteness, which is both light and heavy. Their art of rendering transparency without shine, a luminous opacity. I use paradoxical terms because it's hard to explain the obsession with "color that doesn't exist," as Edgar Allan Poe said, that just might be sky blue. Or a buried time that still lives under its sediments, as in fairy tales when a dream princess awakens, achy after a long sleep.

Giotto and Masaccio's fresco art simultaneously expresses weight and lightness, fluidity and torpor, a certain state of somno-lence and fleeing, a bit like Bach's variations and fugues, in which fleeting movements allow sublime song—the "golden fruit"—to break through. The ancient recipe for *casearti*, which can subtly portray air and time, is casein, gesso, and plaster, added to ground colors. The old methods had to be rediscovered to achieve what I desired. It's clear that I find the ready-made acrylics used by most modern painters a real aberration. Under these conditions, how can the dream and mystery of what one chooses to paint be attained? How could I have captured the "face" of sleep in *The Sleeping Woman*, painted in 1954, if I'd used such radically instant methods?

The same is true of *The Horsewoman* (1941), *Odalisques* (1959) that recalls Delacroix's paintings of Algerian women in their apart-ment, *Sleeping Young Girls* and *Dreaming Young Girls* (1955, 1959), *Fruits* full of their juice (1983), and shivering *Butterflies* (1959–1960). All transcribe the bewitching and gradual torpor of things and people, the other life that they possess. A feverish impres-sion that angels' wings tremble, underlining the fragile weightiness of wings, as angels pass by.

96

Speaking of angels doesn't necessarily mean that religion and painting are connected. The only relationship between the two is in the connection that each has with the infinite and invisible. During my youth, there was a misunderstanding by critics and those who "made" painting careers by flinging their own brand of anathema, praise, and prohibitions. In the abstract euphoria of the day, I was accused of being a figurative painter because no one could imagine that my painting could have any other purpose than representation. In fact I was instructed early on by my acute attention to ancient art. The great masters of sacred and religious painting in the West and East are not only figurative. Certainly they indicate and show things, but above all they provide a vision beyond. The painting displaces the eye, which turns inward, meditating and addressing the great spiritual questions. Indeed it would be useless and unoriginal to simply be figurative without inspiring any internal echo. The great painting of the Middle Ages, and that of holy India, express an internal theology; what is shown has a revelatory purpose, and what is transcribed on canvas leads to personal reflection and spiritual ascent. To a metamorphosis. In this way, paint-

ing and religion are connected, because they are both tools of transformation, means of approach to alchemy.

Sometimes in studying a painting, I am suddenly certain of being in front of something immense and vertiginous. The human face can open quickly and give way to incredible, awe-inspiring worlds. At such a moment, I'm in a religious state and a holy place. The painter must aim at attaining this goal. Otherwise, his painting is mere technique and skill. But technique can help to advance along the pathway.

97

Some of my paintings are autobiographies in themselves, suggesting that I should stop writing my memoirs, since I've long been convinced that I express the most about myself in my paintings. For example, I truly believe that the Chassy and Montecalvello landscapes sum up what I am, and gave meaning to my personal story. In the interior mathematics that completes my canvases, I see the union of Chinese art with Poussin's French art, and Sung painting with Cézanne. A truly sacred, magical action unites civilizations and centuries. I notice many facets of my personality, still fierce and untamed, as they are tuned in to tender things. From my childhood and youth filled with travels to the fulfilling life at Rossinière, limited only by my frailty.

Neither old age nor the tireless flow of seasons can interrupt the dialogue with painting. Only death will stop my daily visits to the studio. For now it is an endless joy to relish Nicot's herb while I look at the painting-in-progress, do my work well, and like any good Christian, accomplish what I was created to do.[15]

15. Jean Nicot (c.1530–1600), a French diplomat, first brought tobacco into France.

98

When all is said and done, I've only been myself. Faithful to what I believe I knew, the old masters' legacy and skill, my childhood, plus what evolved from education. I've never allowed myself to be cosseted by the song of false sirens, trends, or aesthetic fads of which my generation has been so fond. At the risk of sounding stubborn and unyielding, I've only done what I wanted. Or at least what my conscience and instinct prompted. Obedient to what my hand dictated and what Spirituality allowed me to see and transcribe. I've always avoided the pitfalls of schools, groups, academies, and salons, although I've been Classical, out of admiration for French painting's great masters, and Romantic in my Heathcliff style. My painting develops on a solitary path where all words are prohibited, to reach what is essential. That's why I could never comment on my paintings. Nonetheless, according to my writer friends, they are suitable for literary analysis. But all interpretations occur after the fact. To paint is to start with something unknown to oneself that is executed almost miraculously. It's about witnessing what is invisible, a risky and fateful adventure, a true "mystery" in the medieval sense of the word. What takes place in *Cat at the Mirror II* or *The*

Little Rising? The painter is unaware of the scene's meaning, show-
ing a subject on canvas that commands his attention, the result of
personal memories, his painterly skill, and previous artists. The
young girl who climbs a ladder to pick cherries is a distant sister of
one who does the same thing in Poussin's Arcadian landscape.
What can one say to complement this? The only goal is to achieve
deep spiritual beauty, located far from the world, on canvas.

Painting consists of this fascinating adventure, always making
it advance. It seems to be nearly nothing, a stretched canvas, a few
brushes, paint tubes, and color pots. That's where it all begins.
Nothing must be trickery or habitual; one must go back to sources
and creation. Painting means returning daily to the source, and
drawing its water, its light.

99

I rediscovered the light and its innocence when Harumi was still a little girl. Hours spent with Setsuko secretly preparing for the birthdays of our only daughter were happy, miraculous moments safe from passing time. The Countess loves telling traditional stories from her country, fantastic and marvelous tales in which children encounter terrifying dragons and shooting stars, and the extraordinary becomes natural, as in our beloved *Alice in Wonderland*. Setsuko prepared costumes for statuettes made of wood and paste, and we performed real theatrical shows, to Harumi's delight. I sang and told stories, mixing famous arias from Mozart's operas with traditional Japanese characters. It all appeared so natural. Harumi brought us totally innocent grace, something fluid and light, sweet and calm, like my painting of a moth entering a sleeping girl's room.

100

Each time I whisper a few words, I see that they are only remnants and scraps of a richer life, full of material that was entirely consumed by the activity of painting. Snatched from the disaster of old age, these memories of Fellini or Malraux and the inspiration they provided still exist outside of painting. I think of what the Church's Little Saint, Thérèse of Lisieux, said when explaining the story of her life: a full thimble is worth as much as a full wineskin. What's important is that the thimble be full, that the container is filled by what is contained. I'd like these memoirs—even if the term seems too serious—to have the fullness of which Thérèse spoke. I've lived awhile on earth in the exaltation of painting, as a vocation in the religious sense of the word. I was devoted to painting, having no other duties than each painting condemned me to: to finish the canvas and rework the design. I've lived each canvas as a further step along the endless and inexhaustible highway of knowledge. Each one was a further key to revealing secrets; what mystery in that relentlessness, and what secrets in obsessive constraints, both marvelous and ferocious!

I've had no other life but this one. Those who believe that I fab-
ricated legends will get nothing for their troubles. My only life was
this one, the story of a painter facing his canvas, the combat and
connections that they weave each day to attain elucidations and fur-
ther meaning. I've always believed in Oriental wisdom's disarming
simplicity. In the fact that "heaven gives to man to the extent that
man is capable of receiving," as the Chinese painter Shitao said.
That's why one must always be ready to receive and give.

IOI

I often think of Charles Péguy's words from *Our Youth*, pro-claiming that his generation was "a somewhat isolated rearguard, almost abandoned on occasion. A troupe in a state of confusion . . . We will be archives, fossils, witnesses, survivors from this historic age." My duty as a painter has always been to try to preserve colors, and bear witness with the colors that Italian painters used to high-light their paintings and express wonderment. How can this aston-ishing palette of colors be maintained when modern society, full of death and artifice, has distorted colors, perversely making them hard and unrelenting, when color should be a passage, a way to get across, a path for going beyond visible forms?

I think of the yellow mustard gas that killed so many men in the trenches during the First World War, and the blue gas that annihilated Jews in the camps. We've managed to make colors that kill, as sowers of death. As Péguy would say, let's do archival work, refusing industrial colors, sources of death and frigidity, and redis-cover the blue of the skies and yellow of the fields, gold and azure, Giotto's chalky blue and Poussin's vibrant yellow wheat. Giacometti was enraptured by the inaccessible mystery of faces and flowers. A

painter's work is to meet these secrets, in their pristine freshness.

I've located my quest and duty on the childlike path of colors. I cannot overstate the need of preserving it, of always staying close to it. Remaining in the resonance of Mozart's bells.

102

Esteem, official honors, public and critical recognition have never been objectives or motivating forces for me. I've always disdained success. What matters is to advance alone on beauty's path, never straying, and so I never sought anything. Recognition came in spite of myself, even sometimes when I felt I didn't deserve it. For example, when I was given an honorary doctorate by the faculty in Poland. Not that I wasn't worthy, but I felt there was something ironic about it, since in my youth I was always a solitary wanderer, who learned by doing, never attending any school. Painting is such a humbling adventure that it seems unwarranted to receive academic titles for it. But our dear friend the Polish Cardinal Gulbinowicz convinced me to accept the honor.[16] In memory of my Polish origins and my father, he told me.

The Cardinal sometimes comes to see us in Rossinière. He's a marvelous conversationalist who speaks about the Christian faith with accuracy and truth. Countess Setsuko, who has the status of a catechumen, preparing for baptism, learns a lot from him. To

16. Cardinal Roman Henryk Gulbinowicz, born in Lithuania, was named Archbishop of Wroclaw, Poland, in 1976 by Pope Paul VI.

return to my subject, painting is a gesture [*geste*] in the medieval sense of the word, in its own way a personal epic, advancing meaningfully. How can one be satisfied with worldly hubbub and even participate in it? My life choices were not misanthropic, but aimed at solitude, to join the untamed heart of things, and the tightest knot of mystery. Paris and a quest for honors cannot fulfill this profound desire. To arrive at nourishing work requires Chassy's harsh calm, the cour de Rohan's bare studio, Montecalvello's austere hauteur, and Rossinière's affection. I believe that every second of my time has been devoted to painting. Everything has always been with respect to painting. It's a sacred and fateful story.

103

I believe that at the end of human life, one reaches something unadorned and essential, a kind of simplicity that eschews convoluted intellectual questioning. Romanticism and the anguish caused by it belong to youth, but with old age, everything is resolved and simplified, assembled as in Chinese ideograms. Henceforth one day breeds another, that must be given to painting, the pursuit of work until God finally wants to summon you to Him. It's as simple as that. God provides for you. You must not worry about tomorrow. Continue to relish the sweetness of evening that falls on Rossinière, listen to Mob's soft whistle as it snakes along the mountain, and drink at Mozart's source. With time, things lose their harshness and asperity. They are seen differently, and sometimes vanish from view. Time's shrinking of the little that remains is to be fully accepted; one knows that time is limited, yet it is vast and infinite. This is the whole paradox of life. Perhaps the infinity that one glimpses more clearly is already a premonition of God's infinity, another idea of time that is necessarily ushered in. Now, despite the vicissitudes and constraints of old age, many things become minor, making room for what is essen-

tial. It's a sublime impoverishment that clarifies the dross of human life and the hazards of our condition. One should die amid the sweet promise of meeting God, in the splendor for which, I'm convinced, painting always sought to pave the way. To paint means to approach. Close to a light. The light.

104

Because of light, I loved Picasso for his constant and demanding work—although pursued differently from my own. In a letter I wrote to him, I called it "the great river of nourishing and exterminating fire." This channeled his painting, bringing him the flow of life and its necessary sap, when it was about to disappear and die in the great dilution of intellectualism and useless abstraction. We were close, although we didn't see each other often. I loved his stubborn, furious, feverish, and iconoclastic quest. He surely loved what I represented in his eyes: patience, solitude, silence, and a manner of progressing, too slowly for him. In 1941, when he bought *The Children*, I understood why he had chosen that particular canvas. It expresses a melancholy and suspended time, for which he felt a deep nostalgia. Certainly behind the canvas he sensed something about death and childhood, secretly connected in his eyes, something about disappearance that made up part of the common story that we shared in this work. Picasso always furiously painted time's profound vertigo, as a tireless and solar way of destroying in order to accomplish, to burn in order to vanquish, to provoke in order to rediscover. We were on the same line, the

same path, only our way of exploring was different. For this reason, Picasso was my brother.

I recall an evening we spent together, along with Laurence Bataille, at the time when he bought *The Children*. Picasso continually made compliments to the point where I cannot repeat them today, although I recall their essence. At the time before the great retirements, we lived in this companionship—the great encounters at Chassy, Rome, and the En-Haut region.

105

To paint is to emerge from yourself, forget yourself, and prefer anonymity, sometimes while contradicting your own time and those close to you. Trendiness must be rejected. Cling to what you believe is right for you at all costs, and even develop what I—like nineteenth-century dandies—always called the "aristocratic taste for displeasing." Knowing the subtle pleasure in being different destines you for incredible, amazing tasks. In my view, all markets, trends, and snobbery work against a painter. He is beyond fashion. Giacometti understood this. When the cour de Rohan painters, who formed a solid little group, met at the Café de Flore or the Deux-Magots, Alberto Giacometti never came, as he worked all night long; it pleased me to know that good Alberto was awake while Paris had fun or slept. With this view of life, one can't earn much money. But is that really the goal? I didn't want to seek the "fame thing," as my own son sometimes urged me to, in order to become rich and renowned. I think of the "thing" that triggers a fortune, that might have slotted me into a category forever, as in the careers—rather than vocations—of Salvador Dalí, Buffet, or Vasarely. They vied with each other to produce canvases that can

be recopied, but did not advance knowledge by an inch. For paint-
ing is primarily a desire to know and do everything to bring things
to light.

I was never concerned with fame. I merely knew that the path
of painting is among the most difficult of all, and I'd need a lot of
patience and quiet before my work would be recognized and
accepted. I was most sure about my future vocation as a painter
during my adolescence. During my vacations at Beatenberg, where
I painted frescoes in the small village chapel, I told all visitors that
it was "the work of a young painter who'll become famous."

Youthful insouciance, with an innocent smile on one's lips!

106

What interests me is the awakening of things and life, the birth of things. I've constantly worked to paint these childhood secrets. That's why I loved Giacometti. He gave me the proportion of things, giving me the right tone, the one that conveys music, making faces and landscapes sing. That was my only quest, or task. This artisan's labor is not particularly brilliant. It's an obscure, slow, and silent pathway. That's why I abhor being called an artist. I'm like my beloved Captain Haddock who saw the word as an insult that made him curse all the more![17]

Nothing exists but these brushes, this easel and canvas. That's what justified my whole life. Money and fame never affected me. In any case, these days my canvases cost too much. How could I afford them, now that I'm in debt and so stingily unproductive? Some might call my lifestyle luxurious. I've attained it by swapping my paintings for a home where I knew I could fulfill myself, and some furnishings. That's how I decorated

17. Captain Archibald Haddock, renowned for his oaths, in Hergé's popular *Tintin* series of comic-book albums.

Montecalvello, by giving some drawings to a decorator who pret-
tily furnished the château.

The gentle, secret, and intuitive relationship with the canvas is
the best and fundamental part of my life. The striving toward what
is invisible. A painter's required labor.

107

In 1995, I wrote a speech for the Chinese people on the occasion of an exhibit in Beijing. I told them to be lenient with me, for what I offered was "the work of a man seeking to escape the chaos governing the end of the twentieth century." Basically, that might be the final word, explanation, or meaning, if you like, to give to this enterprise of so many years consecrated by absolute devotion to painting. To raise oneself up toward beauty, and supplant grief and suffering by rediscovering childhood innocence. Therefore, create sacred work, because it's a way out of chaos. Just as God took the shapelessness He found at the Earth's beginning and shaped it to attain what is unique. To wear God's face, to consider what He incarnates: landscape, young girls' firm flesh, newly ripe spring fruits, trees full of sap, and the sweetness of sleeping children. I know that this work must mean redemption and salvation. That's why I've always loathed transcribing the painful and inevitable difficulties of the ego. A painter is just a humble conveyor of images, an obedient artisan who can preserve them by patient degrees.

Therein lies his task. Therein lies his accomplishment.

ALAIN VIRCONDELET

Born in Algeria, Alain Vircondelet moved at age eighteen to France, where he published biographies of Duras, Saint-Exupéry, and Pope John Paul II, as well as studies on Camus, Huysmans, and Pascal. Based in the Gascony region, he has also written a number of books on Algeria.

BENJAMIN IRVY

Benjamin Irvy is a poet and biographer (Ravel, Poulenc, Rimbaud) who has translated works by Jules Verne and André Gide, as well as a biography of Albert Camus.